Secrets of
DRAWING
FIGURES AND FACES

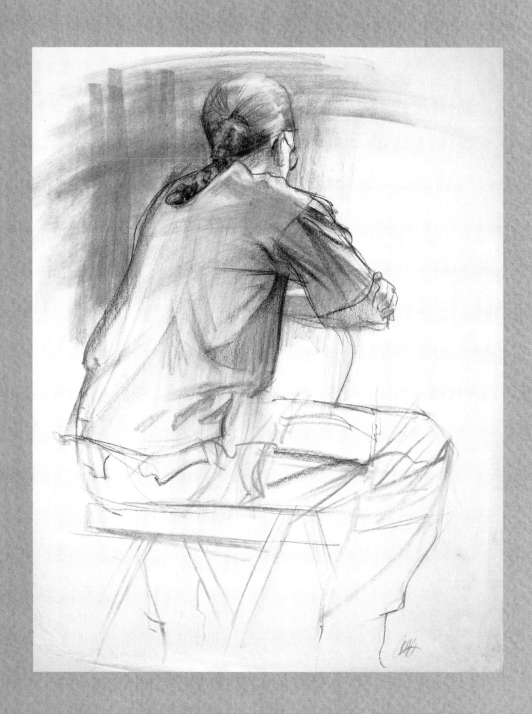

❧ ESSENTIAL ARTIST TECHNIQUES *❧*

Secrets of
DRAWING
FIGURES AND FACES

Craig Nelson

NORTH LIGHT BOOKS
CINCINNATI, OHIO
www.artistsnetwork.com

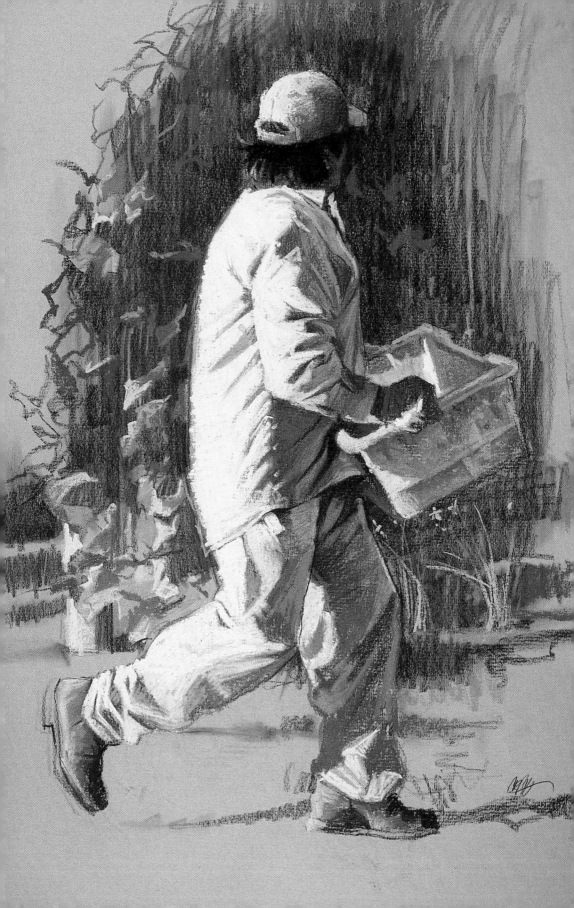

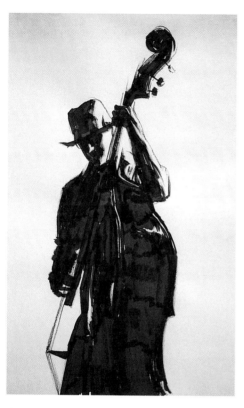

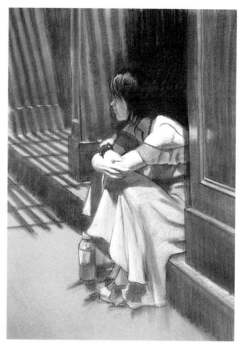

A Seat in Soho
Charcoal and pastel on gray Canson
24" × 18" (61cm × 46cm)

The Bass Fiddle
India ink brush and oil pastel on white artists' vellum
22" × 17" (56cm × 43cm)

The Vineyard Worker
Charcoal and pastel on gray Canson paper
24" × 18" (61cm x 46cm)

CONTENTS

CHAPTER ONE

10 MATERIALS AND TECHNIQUES

12 Drawing Mediums and Tools

14 Graphite

17 Charcoal

20 Conté

24 Colored Pencils

30 Pastel

33 Drawing Pens

37 Ink

42 Drawing Surfaces

50 Working With Line and Tone

51 Hard-Line Drawings

52 Soft-Line Drawings

53 Tone

54 Value

CHAPTER TWO

56 DRAWING FIGURES AND FACES

58 Sketching Figures

60 Pose

62 Posing Models

64 Balance

65 Seated and Reclining Figures

66 Angles

68 Rhythm

70 Pose and Attitude

71 Rendering Attitude

72 Clothing Your Figures

74 Drawing a Man in a Shirt and Vest

78 Drawing Heads and Faces

79 Proportions in Drawing Faces

81 Drawing Eyes and Eyebrows

82 Drawing Mouths

83 Drawing Noses

84 Drawing Ears

85 Male Faces

86 Drawing a Male Face

89 Female Faces

90 Drawing a Female Face

93 Caricatures

Lauren
Charcoal pencil on heavy bond paper
22" × 17" (56cm × 43cm)

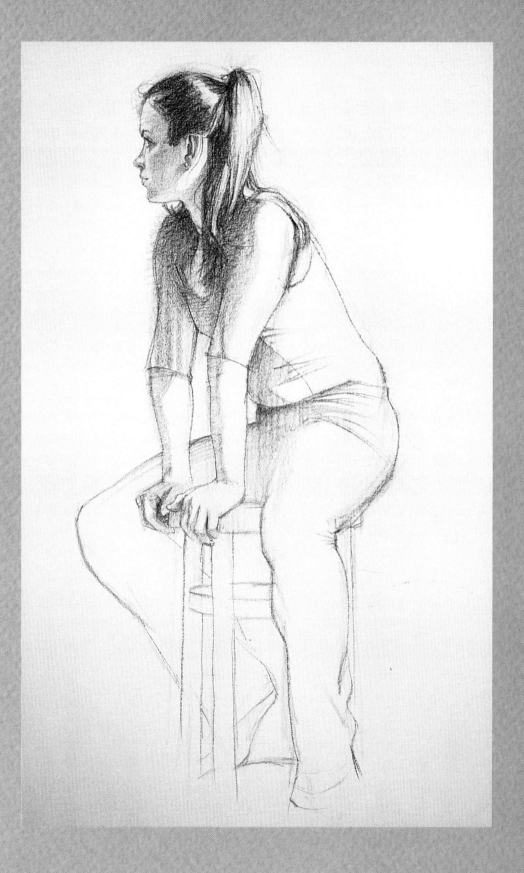

INTRODUCTION

Drawing is the one artistic endeavor that everyone has experienced at some time. It was most likely the first written form of communication, and continues to be a favorite leisure activity.

It is the seemingly magical act of drawing that captivates the heart and imagination of so many. The thrill of making a group of marks create an image offers a special sense of accomplishment. As a child matures, each new year brings a greater awareness of how to make those marks accurately reflect the subject he or she chooses to depict.

The act of drawing is timeless. Although mediums, techniques and concepts have changed, the use of marks and tones has always been the foundation on which drawings are made. Beginning with a blank page and ending with a pleasing image can be a rewarding experience. As in any endeavor, improvement comes with practice and repetition. Eye-hand coordination and sensitivity to mediums may be developed through experience.

Today, those who engage in the art form known as drawing work on a variety of levels. There are those who doodle, those who sketch for fun, those who draw for a living, and those who draw for the sheer aesthetic beauty of drawing. Whatever the motive, drawing is something that everyone can enjoy and grow with. It takes only desire and practice, practice and more practice. The satisfaction of creating an outstanding drawing is hard to beat, so pick up your pencils, pens, markers, charcoals or pastels and enjoy!

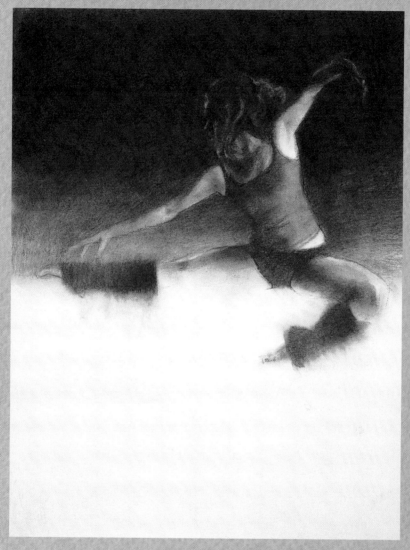

Dancer's Leap
Charcoal and black pastel on artists' vellum
20" × 18" (51cm × 46cm)

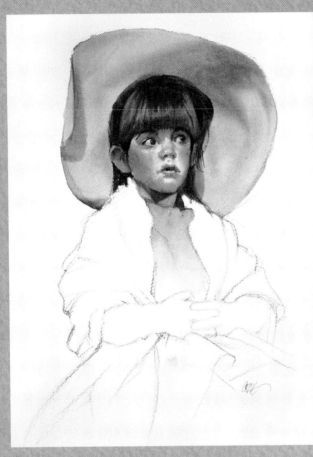

◄
Mom's Big Hat
Graphite and watercolor on rough watercolor paper
16" × 12" (41cm × 30cm)

▼
Dance Pose
Graphite pencil on ledger paper
14" × 11" (36cm × 28cm)

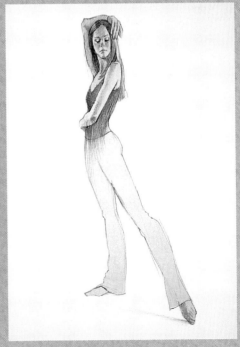

MATERIALS AND TECHNIQUES

Just about anything that can make marks or tones may be used for drawing. The yellow-jacketed no. 2 graphite pencil with an eraser that we are all familiar with is usually our first drawing tool.

However, even graphite comes in various degrees of hardness, offering a variety of tones. There are many other types of mediums that all have unique characteristics and therefore offer unique drawing opportunities. Try as many as you can.

Drawing Mediums and Tools

Drawing mediums are referred to as either dry or wet. Both types can be combined in countless ways to produce everything from quick, hard contour lines to rich, graceful gradations.

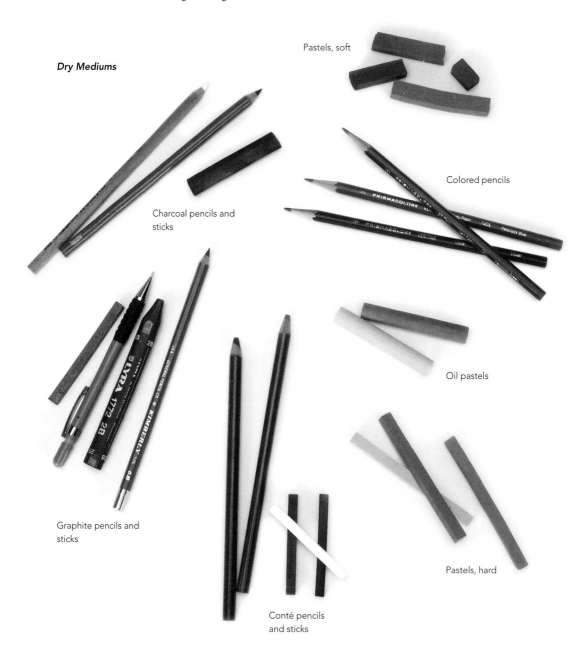

Pastels, soft

Dry Mediums

Charcoal pencils and sticks

Colored pencils

Graphite pencils and sticks

Oil pastels

Pastels, hard

Conté pencils and sticks

Wet Mediums

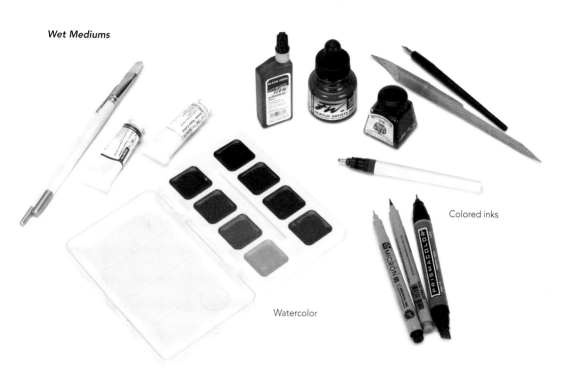

Colored inks

Watercolor

DRAWING TOOLS

The proper drawing tools combined with your chosen mediums and surfaces will help you achieve your artistic vision. Here are some tools you may find useful.

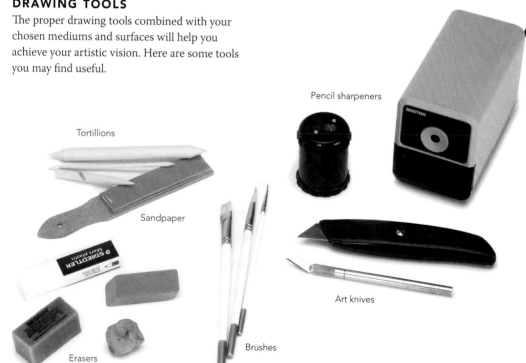

Pencil sharpeners

Tortillions

Sandpaper

Art knives

Erasers

Brushes

Graphite

Graphite is most commonly referred to as pencil. However, graphite is a specific type of pencil that produces silvery blacks, and it comes in sticks as well as pencils.

Forms of Graphite

Pencils are best for detailed work, while graphite sticks are good for creating large tonal areas. Mechanical pencils, for which a variety of leads are available, are a favorite of many artists.

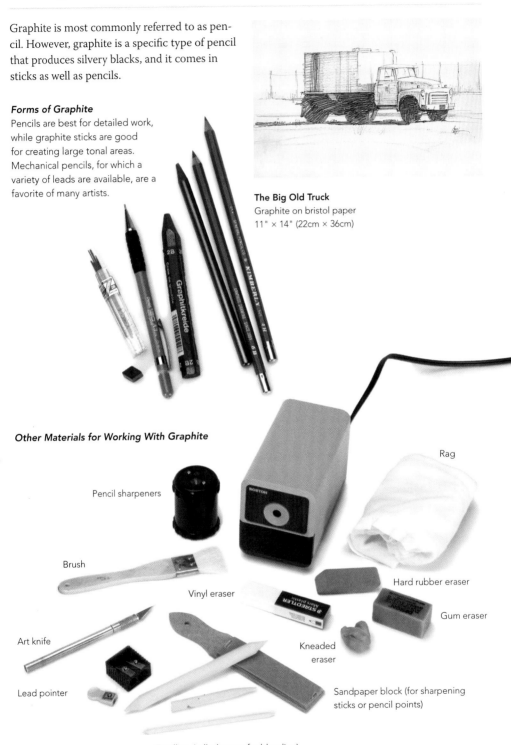

The Big Old Truck
Graphite on bristol paper
11" × 14" (22cm × 36cm)

Other Materials for Working With Graphite

Rag

Pencil sharpeners

Brush

Vinyl eraser

Hard rubber eraser

Gum eraser

Art knife

Kneaded eraser

Lead pointer

Sandpaper block (for sharpening sticks or pencil points)

Tortillion (rolled paper for blending)

Characteristics

Artist's graphite is a combination of graphite and clay. The higher the proportion of graphite to clay, the softer the medium.

Graphite comes in degrees of hardness from 8H to 6B (the *H* refers to hard and the *B* designates black). Hard graphite (H) is good for fine details. Soft graphite (B) can produce a wider range of tones than hard graphite and is good for large tonal areas. Soft graphite requires sharpening more often than hard.

HARD

SOFT

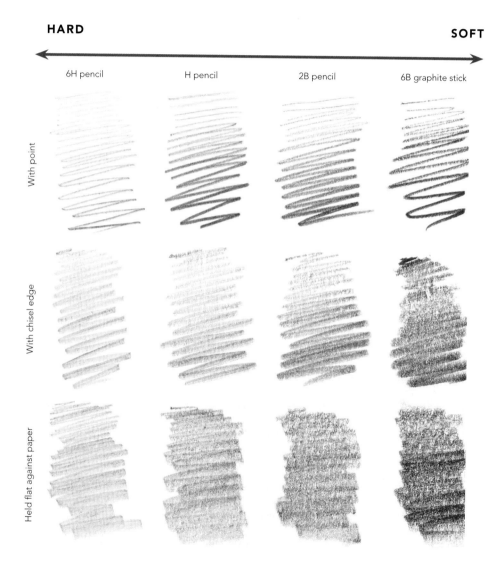

6H pencil · H pencil · 2B pencil · 6B graphite stick

With point

With chisel edge

Held flat against paper

Techniques

LIFTING OUT

The complement of the graphite pencil is the eraser. A kneaded eraser is pliable and is great for picking out soft whites. The hard eraser is better for adding crisp whites.

HATCHING AND CROSSHATCHING

Hatching is a closely spaced series of lines, usually parallel. Hatching is used for shading, shaping and building texture.

Crosshatching is hatching done in layers so that the lines intersect each other. By adding layers of crosshatching, you can increase the density and darken the value in small increments. This makes crosshatching an ideal technique for creating shadows.

Lifting Out

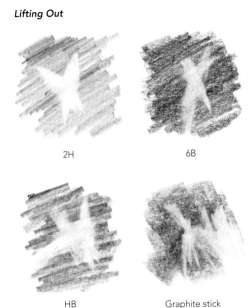

2H

6B

HB

Graphite stick

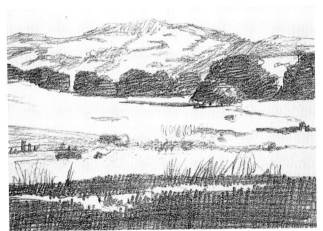

A Quick Graphite Sketch With Crosshatching

Solid tonal shapes and rapid lines make up this sketch. A few soft tones here and there make this a more accurate depiction.

Hillside Landscape
Graphite on ledger paper
5" × 7" (13cm × 18cm)

Charcoal

Charcoal's incredibly rich blacks make it a seductive medium. Since charcoal marks are easily made and can be quite broad, charcoal lends itself to large drawings.

Forms of Charcoal

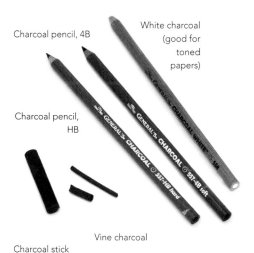

Charcoal pencil, 4B

White charcoal (good for toned papers)

Charcoal pencil, HB

Vine charcoal

Charcoal stick

Long Hair
Charcoal and white charcoal on gray Canson paper
25" × 17" (66cm × 43cm)

Other Materials for Working With Charcoal

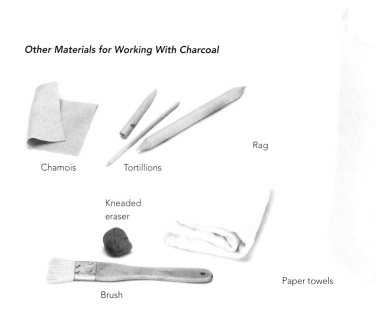

Chamois

Tortillions

Rag

Kneaded eraser

Brush

Paper towels

Characteristics

Charcoal sticks and pencils are made of compressed charcoal. There is also a softer variety called vine charcoal, useful for sketching.

Compressed charcoal, like graphite, comes in varying degrees of hardness. The 2HB through 6B are generally the most desirable.

Charcoal sticks are good for laying down wide strokes, while pencils are better for delicate work. Charcoal pencils are encased in either wood or paper and are less messy than sticks.

White Charcoal Has Many Uses

White charcoal may seem like a contradiction in terms, but white charcoal pencils do exist. White charcoal can be blended with black charcoal or used by itself on toned paper. White charcoal can also be used to cover charcoal stains on white paper.

Vine charcoal

Compressed charcoal

White charcoal on black paper

Charcoal pencil

Techniques

Charcoal is easily blended with tortillions, facial tissue, chamois or even your fingers. As with graphite, you can subtract lines or tone from charcoal by lifting with an eraser.

Because charcoal is soft, the *tooth*, (texture) of your paper greatly affects the look of charcoal marks. Use spray fixative to keep finished charcoal work from smudging.

Vine Charcoal

Lines

Blended

Lifted

Compressed Charcoal

Lines

Blended

Lifted

Take Some of the Mess Out of Charcoal

Wrap charcoal sticks in paper towels or aluminum foil to keep your fingers clean.

Conté

Conté is the trademark name for a chalklike drawing medium. The most familiar Conté colors are rich, warm earth tones, from reddish sanguines to deeper umbers and blacks. For years Conté has been closely associated with figure drawing.

Conté Sticks and Pencils

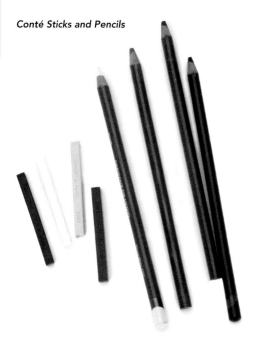

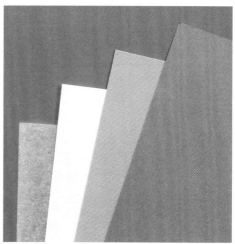

Use Toned Paper With Conté
Conté is an excellent medium for experimenting with different colors of paper. You can use many of the same materials as you use with graphite and charcoal.

Use the Smooth Side of Your Paper

For more control when working with Conté, use the smooth side of your paper.

Characteristics

Like graphite and charcoal, Conté comes in sticks and pencils and in varying degrees of hardness and softness. Conté also comes in different colors: black, white, brown umber (bistre), gray, sanguine orange, sanguine brown and sanguine red.

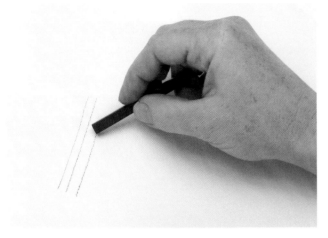

Fine Conté Lines
The shape of a Conté pencil allows you to create lines of varying width. If you want to create thin lines, use the edge of the pencil.

Thick Conté Lines
To vary the size of the lines of Conté sticks, change the angle at which the stick hits the paper. Although you can make wide lines with pencils, they will not be as dark as those made with Conté sticks.

Techniques

Conté has a dry, chalklike feel similar to charcoal. The more pressure you use with Conté, the darker the mark. You might begin a Conté drawing with a lighter color and softer lines and progress to darker colors and more powerful marks. White Conté is good for adding lights on toned papers.

Conté Can Appear Glossy

The harder varieties of Conté can display a rather glossy look—particularly the black.

Blending Conté

You can let your Conté marks show the texture of the paper, or you can blend them with a tortillion for a smooth look.

White over red

White and gray over red

Red over black

Combining Conté Colors

Just a few Conté colors can be blended to produce a variety of effects.

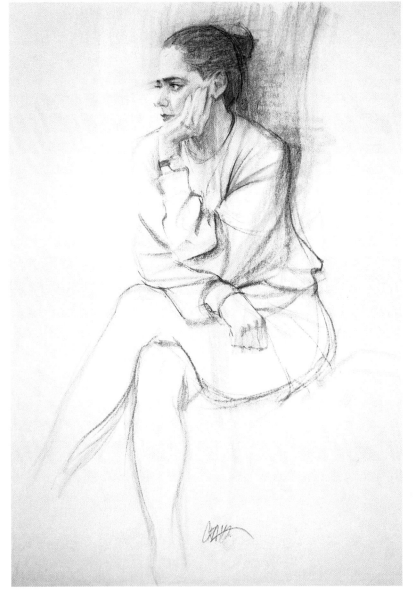

The Figure in Conté
The progression from soft sketch lines to firm, dark lines and tones is left in here, demonstrating the searching nature of the drawing process.

The Look of Determination
Conté on bond paper
23" × 18" (58cm × 46cm)

Colored Pencil

Colored pencils consist of binder, filler, wax and pigment. The more wax a pencil contains, the more smoothly it glides across the paper. Water-soluble colored pencils allow for watercolorlike effects. You can even find color sticks, which are colored pencils without the wood casing.

Prismacolor Verithin (hard)

Colored Pencil Choices

Derwent Aquatone
(water-soluble,
woodless)

Derwent
Watercolor
(water-soluble)

Prismacolor Premier (soft;
somewhat oily feel)

Prismacolor
Watercolor
(water-soluble)

Characteristics

Soft colored pencils provide opaque coverage of the paper surface, and they excel at producing smooth, vivid color. Hard colored pencils have thinner leads that can be sharpened to a fine point, allowing for crisp lines but not for heavy coverage. You can use both kinds in one composition.

With water-soluble colored pencils, you can create fuzzy marks or flowing, luminous washes of color simply by adding water with a brush.

Choosing a Size for Your Color Pencil Work

You might prefer to work smaller when using colored pencil than you would with other mediums. Completing a large, detailed colored pencil piece can be time-consuming. Of course, a loose gesture sketch in colored pencil would take less time.

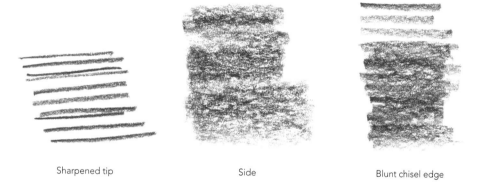

| Sharpened tip | Side | Blunt chisel edge |

Colored Pencil Strokes
Colored pencils can make a wide range of strokes depending on how sharp your pencil is and at what angle you hold it to the paper.

Water-Soluble Colored Pencils
You can soften strokes of water-soluble colored pencil with a brush and clear water.

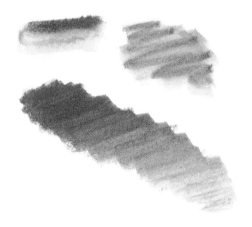

Techniques

BASIC STROKES

Colored pencil strokes can be light or dark, crisp or feathered, delicate or defined.

Choppy

Run the pencil at an angle across paper or a sanding block to achieve a blunt, slanted, "chisel" edge. Use this edge to make firm, short strokes.

Feathered

For feathered strokes, let your pressure on the pencil trail off at the end of the stroke. The result is a gently faded edge.

Tonal Variation

For a gradated tone, increase or decrease your pressure on the pencil as you work across an area.

Defined

A defined stroke has a clear start and stop with no feathering.

Blending With Colored Pencils

A variety of blending techniques can be used to produce shading or to combine colors.

Burnishing
Apply layers of color with firm pressure to achieve an opaque, shiny look.

Layering
With light to medium pressure, lay one color atop another.

Crosshatching
Apply one color with parallel strokes, then add other colors similarly but at different angles.

Your Colored Pencil Palette

Generally two or three each of yellows, oranges, reds, blues, greens and earth tones will suffice, with the addition of one or two flesh tones and possibly black and white.

Water-Soluble Colored Pencils

Water-soluble colored pencils may be used strictly as pencils for sketching, or you can apply water with a soft brush for a fluid look. I think the dry application of lines combined with a touch of water here and there gives optimum balance to this unique medium.

Using Water-Soluble Pencils

Apply water-soluble colored pencil . . .

. . . then brush on water.

Surfaces for Water-Soluble Colored Pencils

A porous surface such as ledger, bristol or watercolor paper works best for this medium.

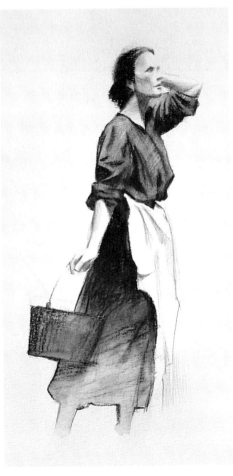

Layered Colored Pencil
Darks have been layered on top of a lighter water tone for strength.

Carry That Pail
Water-soluble colored pencil on watercolor paper
14" × 11" (36cm × 28cm)

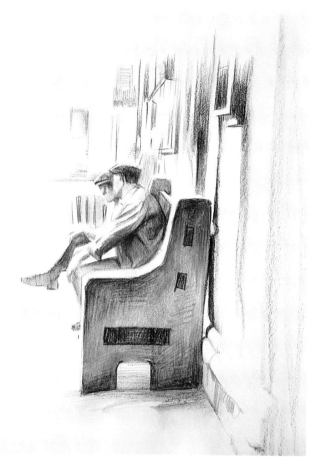

Experiment With Water-Soluble Pencils' Possibilities
Leaving a great deal of white space, combine water tone with dry line work to create a sketchlike quality.

A Couple of Buddies
Water-soluble colored pencil on ledger paper
12" × 9" (30cm × 23cm)

Travel Light With Water-Soluble Pencils

Water-soluble colored pencils make a great travel medium, especially for people who enjoy watercolor painting. There is no need for a palette—just a small water container, a pad, a brush and six to eight pencils.

Pastel

Pastels are composed of the same pigments used in oil paints without the oil binder. It is a great medium for quick sketches or a fully developed painting. A rich array of color is evident in many pastels; however, a simplified palette may be equally intriguing.

Forms of Pastel

Hard pastels

Soft pastels

Pastel pencils

Other Materials for Working With Pastel

Hard Pastels Are Good for Details
This quick, unfinished sketch shows hard pastel on top of a faint charcoal sketch.

Girl With a Scarf
Hard pastel and charcoal
11" × 8" (28cm × 20cm)

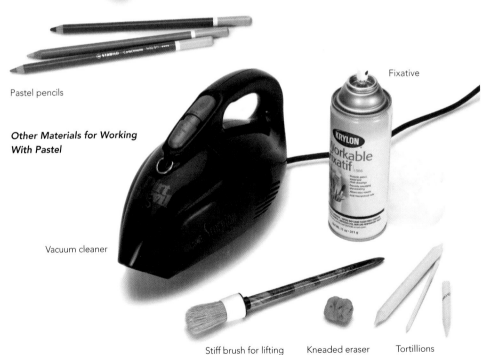

Fixative

Vacuum cleaner

Stiff brush for lifting Kneaded eraser Tortillions

Characteristics

Pastels are made from a combination of chalk, pigment and a binder (usually gum tragacanth) that has been formed into sticks or pencils. The binder holds the pigments together, but pastel needs a paper with a lot of tooth to remain on the surface.

HARD PASTELS

Hard pastels are usually rectangular. Because they contain more binder than soft pastels, they tend to break less often and emit less dust. Sharpened hard pastels are great for linework.

Turned on their sides, hard pastels can be used to create broad areas of color, a useful technique for applying the initial layers of color for a picture.

SOFT PASTELS

Soft pastels tend to be rounder than hard ones and usually are enclosed in a paper sleeve to help prevent breakage. Because they have less binder, soft pastels create more dust and are more easily broken.

Pastel on Cold-Pressed Watercolor Paper

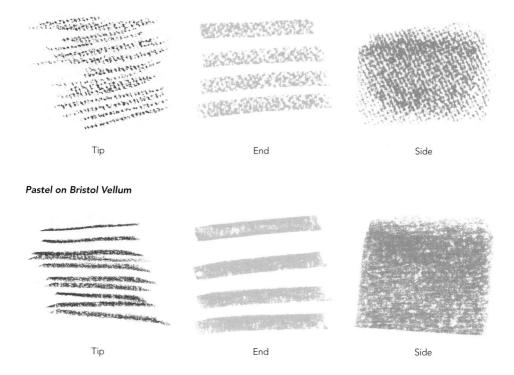

Tip End Side

Pastel on Bristol Vellum

Tip End Side

Techniques

WAYS TO BLEND COLORS

Pastels can be blended with fingers, a tortillion or (for large areas) a rag.

Mingling pastel colors without blending them lets the colors combine visually for a textured effect. A few different ways of doing this:

- *Layering.* Apply one color atop another without blending.
- *Crosshatching.* Apply lines of color at different angles.
- *Scumbling.* Apply one color over another in loose, wide strokes.

Blended

Layered

Sharpening a Pastel Stick
To sharpen the edge of a pastel stick, scrape it with an art knife. Use this technique to sharpen Conté sticks, too.

Crosshatched

Scumbled

Drawing Pens

Many artists use pen in their sketchbooks because marking pens produce sharper lines than pencils. A pen drawing can consist of simple, expressive lines, hatched tones that create volume and form, or both.

Since pen marks are permanent, an artist must draw with conviction. The spontaneous quality of pen drawing contributes to its charm and beauty.

Exterior Contours and Interior Lines

It is possible for a line to begin as an exterior contour and move into an interior line. This may be seen in folds of clothing or in anatomical features.

Hold Your Pen Properly for a Better Drawing

It is important to draw in a free and comfortable fashion. Do not grip your pen tightly, using only your wrist. Instead, keep your arm involved in your drawing. Don't draw as if you are writing; this will result in a stiff drawing devoid of feeling.

Drawing Pens

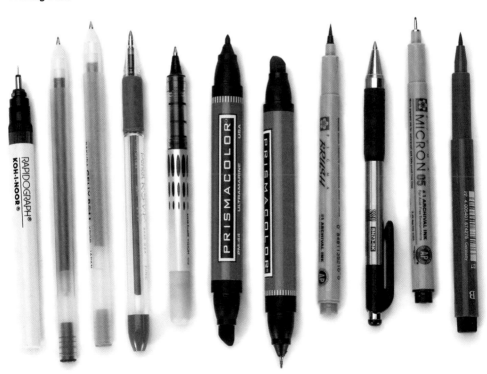

Pens, from left to right: Koh-I-Noor Rapidograph technical pen, Sakura Gelly Roll pens (2), Pentel fine ballpoint pen, Sanford uni-ball Vision roller ball pen, Prismacolor markers (2), Sakura Pigma Micron 0.45mm pen and Faber-Castell PITT artist's pen.

Characteristics

BALLPOINT PENS

Although most commonly used for writing, ballpoint pens are great for quick sketches or for transferring a drawing. Most ballpoint pens are not permanent.

FINE-LINE DRAWING PENS

There is a terrific variety of permanent fine-line drawing pens. A .03 size is probably the best for drawings 11" × 14" (28cm × 36cm) or smaller. However, it is possible to create exciting drawings with bolder pens.

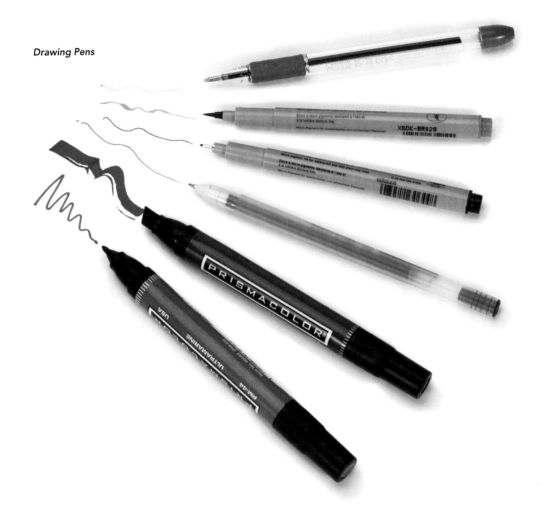

Drawing Pens

TECHNICAL PENS

Technical pens come in three types:

- *Refillable.* This has a plastic cartridge you fill with your choice of ink. You can also choose from a range of point sizes.
- *Disposable cartridge.* This has a plastic cartridge already filled with ink that you replace when empty.
- *Disposable pen.* Throw out the entire pen when it's empty.

FELT-TIP PENS

Felt-tip pens come in various sizes and colors. Experiment to find the pen that works best for you.

BRUSH PENS

Brush pens have a flexible, fibrous point. The pen can make lines of varied widths from fine to broad, like a round paintbrush.

Cleaning Technical Pens

Keeping your technical pens clean is extremely important. Follow the instructions that accompany the pen for specific cleaning techniques.

Techniques

USING PEN

There are two basic types of marks you can make with pen: dots or lines. You can vary both types of marks in size, volume and arrangement. The marks will seem lighter if they are spaced farther apart and will seem darker if they are close together.

Ballpoint pen marks Gelly roll pen marks

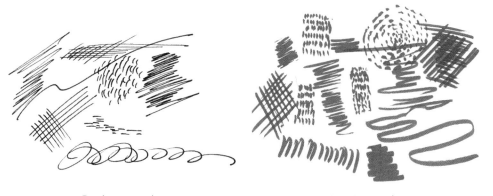

Fine-line pen marks Artists' pen marks

Different Marks Made With Pens
Different types of drawing pens have unique characteristics and will make the same types of marks in slightly different ways. Experiment to find the drawing pen that best suits your purpose.

Ink

Ink is great for quick sketches. Inks come in full-strength liquid form. You can create softer variations of each color by simply diluting them with water.

You can apply ink with a brush, a pen or a stick. Inks are totally additive in nature, mean-ing that once applied, they cannot be lifted from the drawing surface. This is different from working with watercolor, which can be manipulated somewhat after it is laid down.

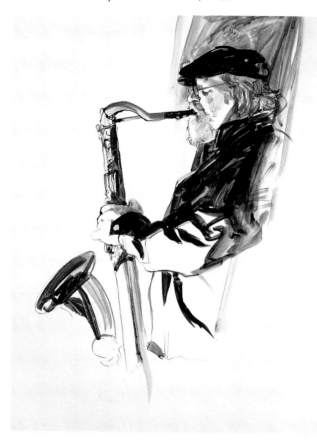

Ink Line and Wash Combined
Slippery, nonporous board lets ink flow easily, showing off brush-strokes.

Patrick's Sax
Ink on cast-coated paper
20" × 16" (51cm × 41cm)

Characteristics

DIP PENS

Dip pens do not have a built-in ink reservoir and must be dipped into a container of ink to pick up a new supply. Their steel nibs are removable and come in many shapes, giving you a range of possible marks.

BAMBOO PENS

These dip pens are made from a slender stick of bamboo. The bamboo is sharpened to a point and split, creating a reservoir for the ink.

ORIENTAL BRUSHES

These are brushes that lend themselves well to drawing with ink. You can get soft, medium and hard tips.

CALLIGRAPHY BRUSHES AND PENS

There are a variety of brushes and pens that are used for calligraphy. The brushes come in many shapes and sizes, and the pens have a variety of nibs to create different ornamental effects.

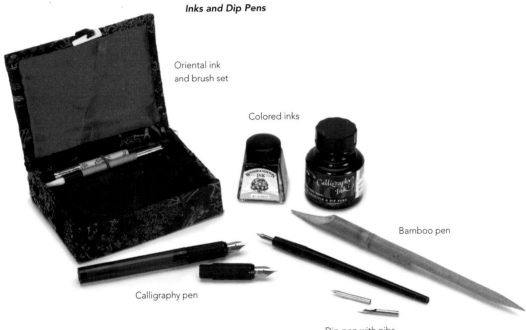

Inks and Dip Pens

Oriental ink and brush set

Colored inks

Bamboo pen

Calligraphy pen

Dip pen with nibs

BLACK INKS

These are made up of fine carbon pigments. When buying black ink, look for a manufacturer's date on the container. Inks that have sat on the shelf for longer than two years may have separated and therefore will not be suitable for use.

COLORED DYE-BASED INKS

Many colored inks are made of impermanent dyes and should therefore be used only for work that does not demand permanence.

COLORED PIGMENTED INKS

These inks work well in technical pens as long as you choose colors that are labeled as transparent.

Inks

A Starter Ink Set

I recommend purchasing two earth tones (one dark, one warm), plus one each of yellow, red, blue, green and black. To add interest, you can also add one or two more colors of shocking intensity.

Techniques

You can use many of the same techniques with ink as you can with drawing pens. What you use to apply the ink greatly affects the way the ink looks on your drawing surface.

Ink applied with a brush

Ink applied with a pen

Choose the Right Ink

When your selecting inks, your drawing surface should also be a consideration. Some inks are made for particular types of surfaces. Be sure to read the labels carefully before you buy.

Pen and Ink With Watercolor

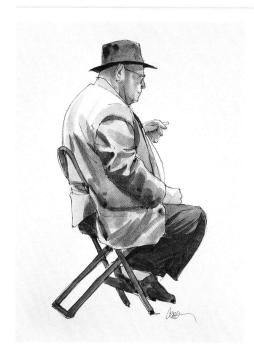

Watercolor is relatively easy for the artist to transport and set up on location. The addition of line brings a new spontaneity to the beauty of the colorful tones. Watercolor may be used as an accent to line, or line may be used to accent watercolor. Many artists prefer to use hatching to deepen some darks, but this is a personal preference.

Watercolor as Accent to Line
This black line contour drawing is brought to life by the addition of light, medium and dark tones from a limited warm earth-tone palette.

Study of a Man in a Hat
Fine-line pen and watercolor
12" × 9" (30cm × 23cm)

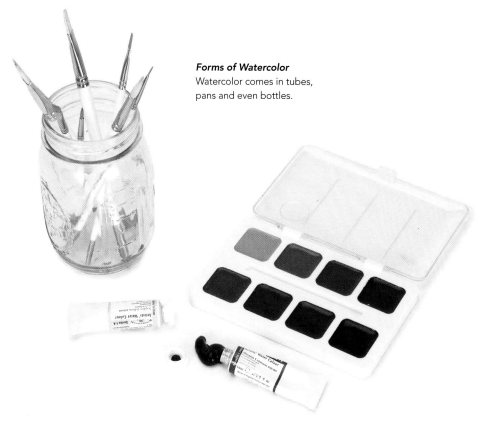

Forms of Watercolor
Watercolor comes in tubes, pans and even bottles.

Drawing Surfaces

The surface you choose for your artwork will contribute greatly to the character of the finished piece. A coarse surface may enhance certain mediums, bringing out the texture and adding variety to the tones. A smooth surface may be more appropriate if you don't want the marks you make to have textured appearance.

Drawing Surfaces

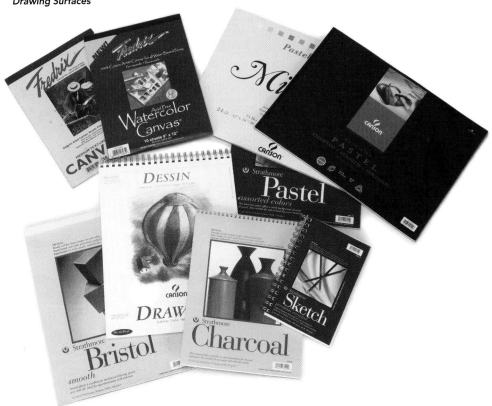

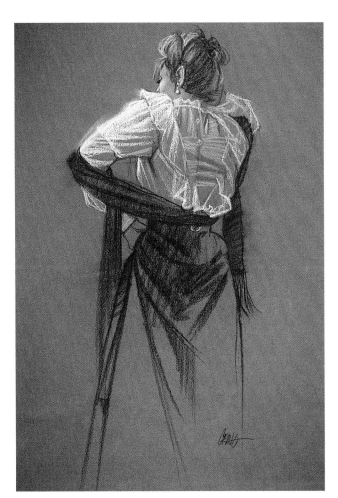

Dark Canson Paper
On dark paper, the white pastel dominates and the dark charcoal supports.

White Bond Paper
Charcoal on simple white bond paper, the most commonly used white paper.

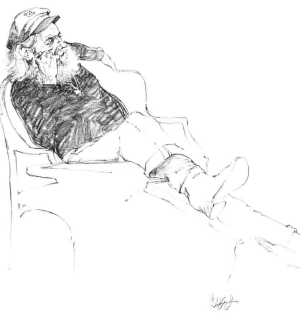

Paper

Choose paper that is acid-free to ensure a long life for your artwork. Also be aware that heavier papers withstand erasing, scratching and rubbing better than lighter papers and do not warp as easily.

CHARCOAL PAPER

Charcoal paper comes in varying degrees of tooth. Although designed for charcoal drawings, you can use it with other mediums such as pastels.

VELLUM

Vellum is a nonporous surface with a slight tooth. It is a good surface for pen-and-ink work, graphite sketches and for oil pastels.

PASTEL PAPER

Like charcoal paper, pastel paper comes in different degrees of tooth and an also be used with other mediums.

WATERCOLOR PAPER

The surface of a paper greatly influences the look of the medium you apply to it. Watercolor paper, best suited for wet mediums, comes in three textures:

- *Hot-pressed.* This has a very smooth surface.
- *Cold-pressed.* This is moderately textured.
- *Rough.* This is highly textured.

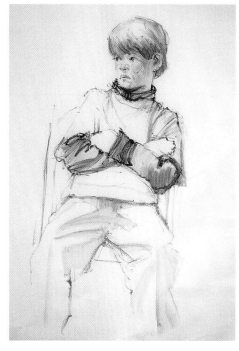

Brendan's Cool Shirt
Oil pastel on vellum
25" × 19" (63cm × 48cm)

From left to right: vellum, charcoal paper, pastel paper (2)

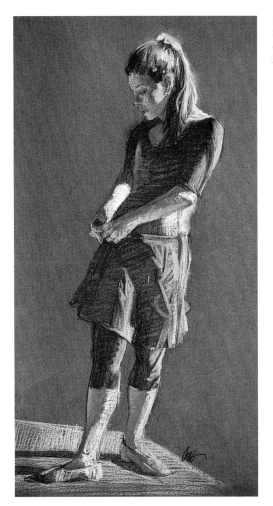

Fixing Her Skirt
Soft pastel and black charcoal pencil
on Canson paper
20" × 12" (51cm × 30cm)

From left to right: rough,
hot-pressed, cold-pressed

Board

Boards are a great option for drawing, especially when working with wet mediums. They are thicker and therefore less likely to warp when washes are applied.

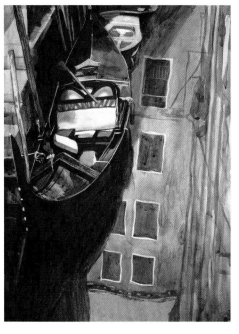

WATERCOLOR BOARD
Watercolor board is watercolor paper glued to a stiff backing of cardboard. Like the paper, watercolor board comes in hot-pressed, cold-pressed and rough textures.

BRISTOL BOARD
Bristol board is created by compressing two or more pieces of paper together. The more paper used, the heavier the weight of the board.

MAT BOARD
Mat board is a type of cardboard that comes in a wide variety of colors and textures. It can be used for drawing or as the border around a framed picture.

From left to right: watercolor board, mat board, bristol board

Gessoed Board
The nonabsorbent quality of gesso is a bit rough, great for textural charcoal and for wash-like stains, which can be layered to build varying grays.

Lone Gondola
Graphite, acrylic, colored pencil and gesso on illustration board
20" × 16" (41cm × 51cm)

Other Types of Surfaces

Exploring other types of surfaces is a lot of fun. Surfaces such as canvas, Yupo and foamcore board can provide exciting and inspirational results.

CANVAS

Canvas may be purchased in roll form, pre-stretched on stretcher strips or mounted on a stiff backing of cardboard or hardboard. It can also be found raw or primed. You can draw on it, but canvas is best suited for oil and acrylic paintings.

SKETCH PAPER AND NEWSPRINT

Inexpensive sketch paper and newsprint are useful for doing quick idea sketches, but they should not be used for finished art as neither one will last. Newsprint is especially problematic because its high-acid content will cause your art to quickly fade.

FOAMCORE

Foamcore is a strong, stiff, lightweight board of plastic fibers with paper laminated on both sides. It comes in many colors and thicknesses. Foamcore is often used as a backing for papers and other surfaces but can be drawn on, too.

YUPO

Yupo may best be described as plastic paper. It's most often used for big, bold watercolors. Yupo is acid-free and archival, but you should spray your work with fixative to prevent the image from smearing.

From left to right: sketch paper, canvas, Yupo, foamcore

Drawing Surface Examples

Experiment with different surfaces and mediums to determine which ones will best suit the subject and your style. A rough surface may be best for capturing the texture of a rocky landscape, while a delicately detailed portrait might be more suited to smooth, coated paper. Choose a surface that will work with you, rather than against you.

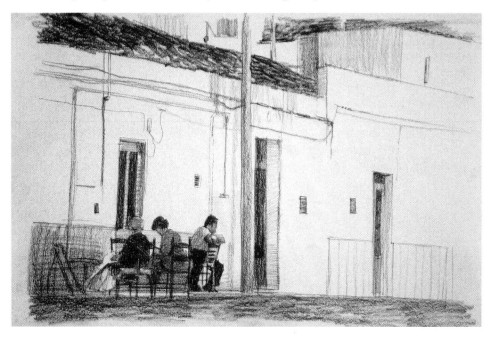

Smooth Paper
Charcoal lines look more refined on a smooth paper. A surface with little texture allows you to smear tones more easily to create softer edges and more gradual value changes. The tone of the paper also softens the highlights.

Small Italian Village
Charcoal on smooth, toned Strathmore drawing paper
11" × 16" (28cm × 41cm)

Gessoed Board
Gesso is nonabsorbent and a bit rough, making it great for textural charcoal and for washlike stains that can be layered to build varying grays.

Family
Charcoal, Conté and acrylic on gessoed board
12" × 9" (30cm × 23cm)

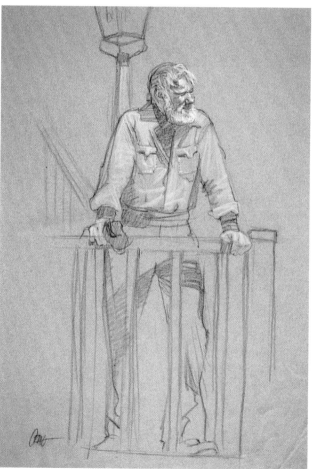

Toned Paper
The neutral gray Canson acts as a great surface for darks and lights, both of which allow the gray to act as the midtone.

The Weathered Sailor
Charcoal and NuPastel on gray Canson paper
24" × 18" (61cm × 46cm)

Working With Line and Tone

When most people think of drawing they envision linework only, without considering the tones we usually associate with painting and photography.

Generally it is more aesthetically pleasing for either line or tone to dominate a drawing, while the other provides the accent. A drawing may consist primarily of line with tone as an accent, or a drawing may be made up of tone accented by line. Use the accent in the drawing's focal point or in an area to which you wish to call more attention.

You may use a variety of mediums in line and tone drawings, or only one. Using both line and tone in your drawings allows you to explore and discover new directions for your work. Starting with line and then adding tone, or developing a group of tones and then unifying it with line can help you express your ideas more fully. Your ability to work with different mediums, approaches and technical applications will improve with practice and repetition. As you experiment you will discover exciting new methods; practice will make you comfortable with them.

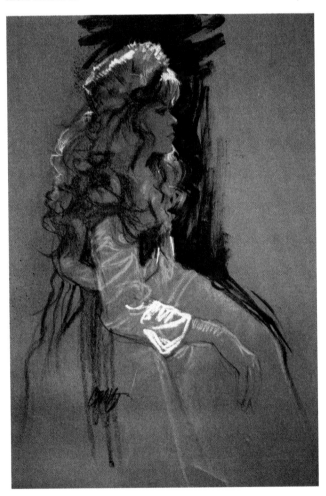

Draw With Confidence
This hard-line drawing shows fluidity, conviction and confidence. The artist betrays no fear of making mistakes.

The Girl in the Hat
Fine-line marker on bristol board
14" × 9" (36cm × 23cm)

Hard-Line Drawings

Line drawings are primarily *contour drawings*. Here, *contour* refers to edges, either exterior edges or interior edges (such as those around belts, collars, eyes and other features). It is also possible for a line to begin as an exterior contour and move into an interior line. This may be seen in folds of clothing or in anatomical features. Hard-line drawings may be precise and formal, or fluid and casual. Pen lines may be thick or thin. Brush, stick or quill lines may vary from thick to thin as well.

Using line exclusively to create a drawing may seem limiting, but, if employed creatively, you can achieve a variety of interesting and charming effects. With practice, your line-drawing ability will develop and become a very satisfying method for creating details.

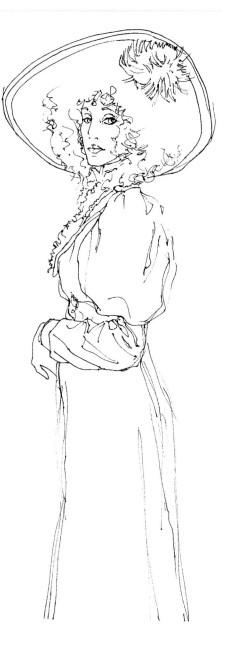

Soft-Line Drawings

Soft-line drawings, such as those done with graphite or charcoal pencil, may consist of neat, crisp lines and soft lines that seem to just fade away. The beauty of soft-line drawings is in the variations of line work you can achieve.

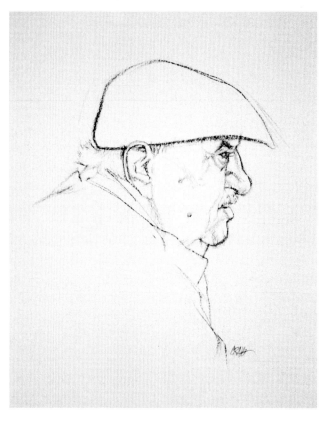

Drawing With Soft Lines
This soft-line drawing employs the variety of line qualities available with charcoal.

An Interesting Profile
Charcoal pencil on ledger paper
10" × 10" (25cm × 25cm)

Combining Hard and Soft Lines

To create variations from hard to soft lines in a drawing:
- Hold the drawing tool loosely. This will enable you to use either the tip or the side.
- Vary the pressure. More pressure will create darker lines and less pressure will create lighter lines.
- Vary the speed with which you make lines to control the precision and character of the line.

Tone

Tone is the term artists use to refer to color and value in the areas between contour lines. Tone covers a broader area than a line and offers more possibilities for variation in value. Tonal drawings define shapes with areas of contrasting value rather than with definite, hard contour lines—the same way our eyes distinguish shapes. Adding tonal values to a sketch can make objects appear more three-dimensional, enhancing form and increasing the viewer's ability to "read" a drawing. Tone may be applied with dry medium such as charcoal or pastel, or it may be added with a wet medium such as an ink wash. The drawing surface itself may also add tone to the artwork.

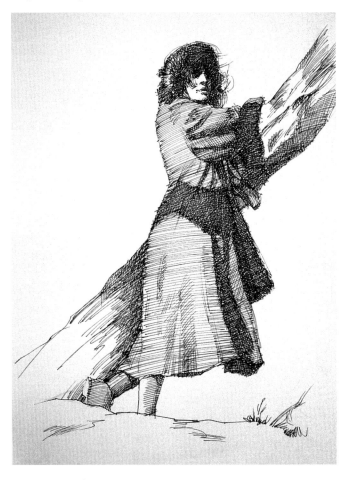

Use a Variety of Tones
Here I used hatching to create the variety of tones in this drawing.
To establish the dark areas, I simply layer the hatching.

An Offshore Breeze
Fine-line technical pen on bristol board
12" × 9" (30cm × 23cm)

Value

Value is the degree of lightness or darkness of a specific tone. Black is at one end of the value scale and white is at the other, with all shades of gray in between. Each color has a corresponding value scale with similar gradations.

Contrasts and variations in value may be used in drawings for many purposes. Value variations can describe and model form, and contrasting values can define shape. Value contrasts may be used to accent an area or draw attention to a specific part of the drawing.

Whether used in conjunction with a line drawing or all by themselves as a tonal drawing, value variations give weight to a composition, create form and establish a three-dimensional quality.

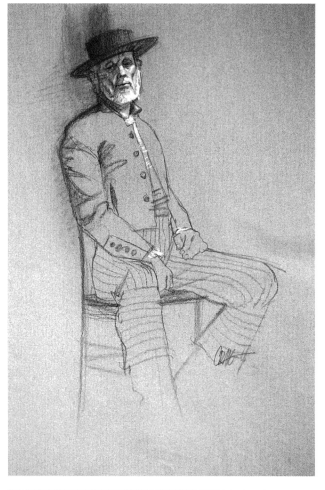

Value Adds Richness
This loose charcoal line drawing has been enriched through the use of value variation. The gray-tone Canson paper acts as a middle value to set off both the dark charcoal and the light Conté.

Spanish Dancer
Charcoal and Conté on
Canson paper
24" × 18" (61cm × 46cm)

Value Scale

USE A RANGE OF VALUES

When creating a range of value for your drawings, gradually build the tones from the lightest to the darkest by applying a darker tone on top of a lighter tone. Using your subject as a reference, continue building layers as required until you reach the extreme darks. This will give you more control over the value range you create.

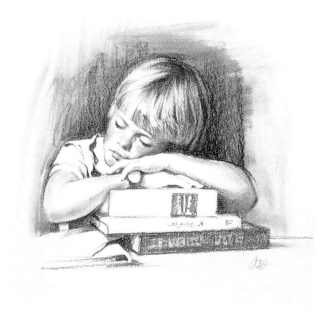

Build Darker Values On Top of Lighter Tones

I chose to use a sanguine pencil for the first tonal layer. Then, I applied charcoal on top to create the darker values.

The Napping Student
CarbOthello pencil and charcoal pencil on vellum
12" × 14"
(30cm × 36cm)

Building Up Tones
Start with lighter tones and layer to make the value darker.

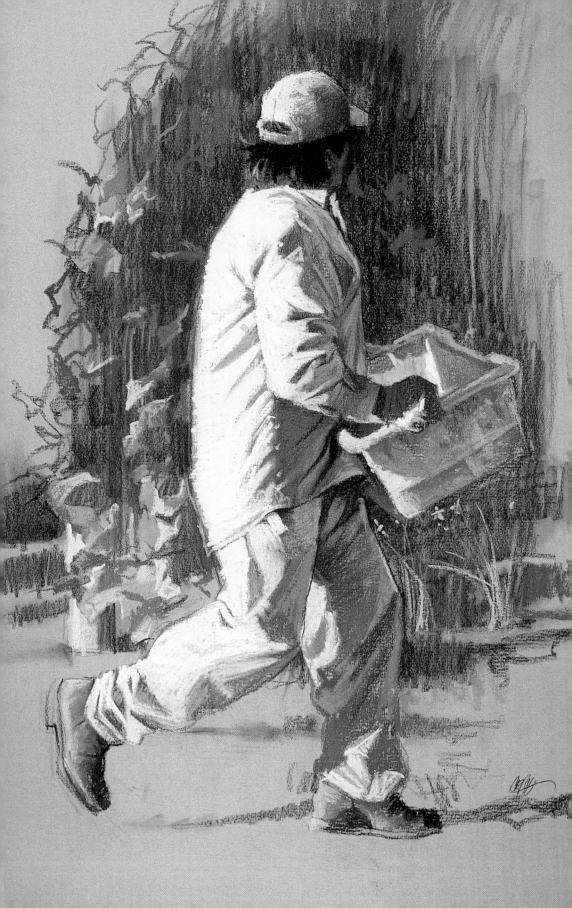

DRAWING FIGURES AND FACES

Gesture and attitude constitute the "body language" of a figure. The angle of the head, the action of the arms, the use of the hands and the weight distribution of the body all play an important role in the attitude and pose of the figure. A great range of expression may be demonstrated through poses and gestures. Seated and standing figures as well as figures in motion can display gestural qualities. With moving figures, it is important to find the moment that best describes the action. In many cases this will be the moment that the action begins, or just prior to the actual movement.

When drawing any figure, it is vital to study and understand the attitude and gesture of that specific figure. Depicting individual attitudes will give life to the figure and help you avoid a static, paper-doll-like quality. Also use clothing to help you render the movement or gesture of a figure. Folds created by tension can be used to amplify the attitude or the action. Using all of the properties of pose and gesture will ensure a more pleasing and believable figure drawing.

The Vineyard Worker
Charcoal and pastel on gray Canson paper
24" x 18" (61cm x 46cm)

Sketching Figures

Once you've determined accurate proportions for a figure drawing, do quick gesture sketches to help you capture these proportions accurately before you start your final drawing. Doing quick gesture sketches will help you capture your figure's attitude. Once you have a sense of the proportions and attitude, you can begin to refine the details that bring out your subject's character.

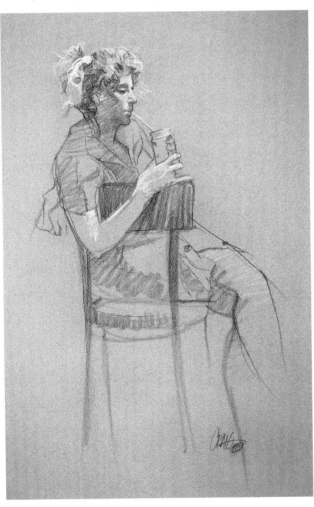

Do Multiple Gesture Sketches
This drawing was created after sketching several poses of this model. By testing several poses with sketches as the waitress moved around, I was able to select the pose with the gestures and character I wanted.

The Waitress
Charcoal and white chalk on Canson paper
22" × 17" (56cm × 43cm)

Proportion in Figure Drawing

Correct proportions are absolutely crucial in figure drawing. Because the figure is so mobile, the proportions seem to change constantly. This makes careful observation a must.

When I draw the figure, I first decide how tall I want to make it. The average adult is 7½ to 8 "heads" tall. (Use 8 or even 9 head lengths if you want to make the person look powerful, dignified and regal.) The groin is about halfway point of an ideally proportioned adult. Then I divide my paper up evenly about (eight head lengths) and use this as a guide for placing different parts of the body.

The ideal height of a woman is shorter than a man's by about half a head, but her total height is still eight head lengths. When drawing children, the head is usually larger in proportion to the body, and the shoulders are narrower.

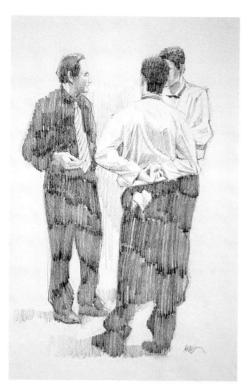

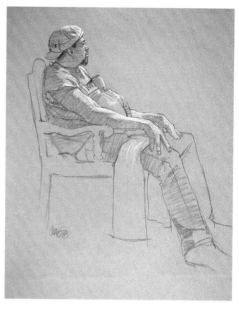

Include Tone in Your Sketches
I used charcoal line and tone for this sketch. The added white Conté helps to create form and interest, while the toned paper accentuates both the darks and the lights. I applied the darker gradated tones loosely to add to the informal character of the drawing.

The Trainer
Charcoal and Conté on toned Canson paper
25" × 19" (63cm × 48cm)

Try Sketching More Than One Figure
This sketch of three figures is composed of large dark masses accented with a little modeling and a touch of line. The pose and attitude of the figures contribute to the sense of an ongoing discussion.

The Discussion
Graphite on ledger paper
14" × 10" (36cm × 25cm)

Ideal Proportions

Determine the type of perspective you will use before you begin drawing. You don't have to plot out your composition exactly, but you should begin with a general idea.

Pose

Figure drawing involves pose, the stance or position of a figure. A pose may capture a figure at rest or in motion, but even stationary poses can exude a sense of energy. Depicting an "active" stance will help you overcome the stiffness figure drawings often have. For example, try putting the weight of your subject on one leg, allowing the other to relax. This will cause the torso to lean slightly to one side for balance. This posing technique is referred to as *contrapposto*. You can enhance this position by placing the hands on the hips or by putting one hand behind the head.

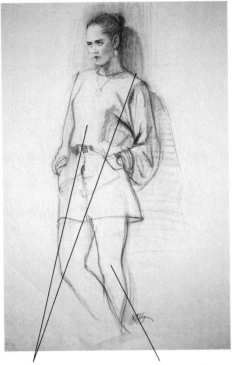

Torso and shoulders lean to the side for balance

Weight on one leg

Contrapposto
The weight of the body is supported on one leg and the wall upon which the figure is leaning.

Supporting Wall
Conté and CarbOthello pencil on bond paper
22" × 17" (56cm × 43cm)

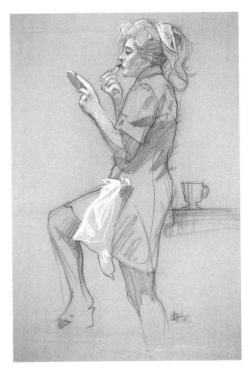

Find Interest in Commonplace Poses
Here I used the pose to suggest the casual attitude of the subject. I accented the sketchlike quality of this drawing with a few casual but thoughtful touches of white to place the focus on the activity of applying lipstick.

Fresh Lipstick
Charcoal and white chalk on gray Canson paper
25" × 19" (63cm × 48cm)

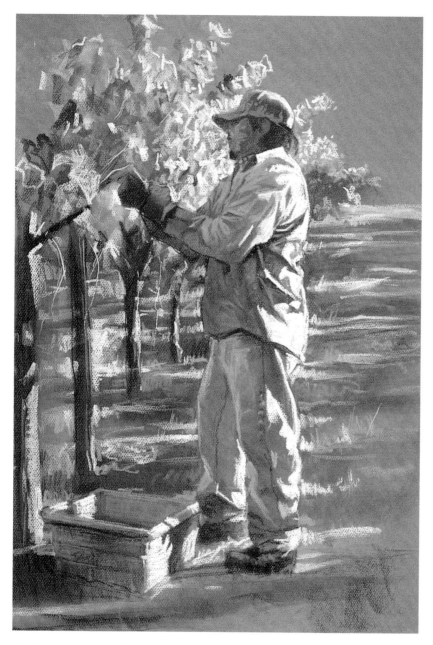

Pay Attention to the Background When Posing Models

In this figure drawing, the weight distributed between the legs is countered by the action of the arms. Figures do not exist in a vacuum, so it's often helpful to show a figure interacting with the environment. The background vines here are indicated in a casual and loose manner. I added pastel over a charcoal sketch for some color and to create the effect of sunlight.

Early Harvest
Pastel and charcoal on gray Canson paper
25" × 19" (63cm × 48cm)

Posing Models

Your subjects for figure drawing may be models, friends willing to pose for a short time or, for quick sketches, folks on park benches or in coffee shops. When posing models, it is important to keep gesture and balance in mind to ensure a nonstatic pose. Consider weight distribution, hand and arm positions, the direction of the upper body, the direction of the lower body and the head. The position should appear comfortable and natural, not obviously posed.

Take time to notice how people sit and stand. Such observation will help you pose models or draw figures from another resource. Candid poses are less likely to appear stiff and unnatural.

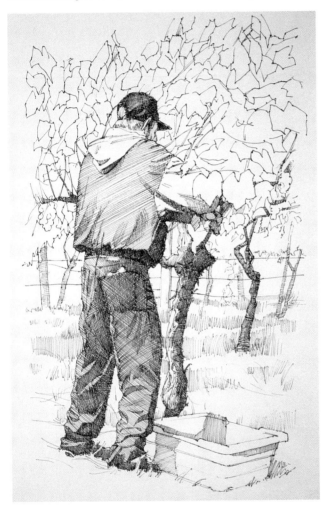

Relate the Figure to the Environment
Take note of "landmarks" on the figure and clothing to make sure that they relate properly to corresponding landmarks in the environment.

Picking
Pen and ink on bristol paper
15" × 9" (38cm × 23cm)

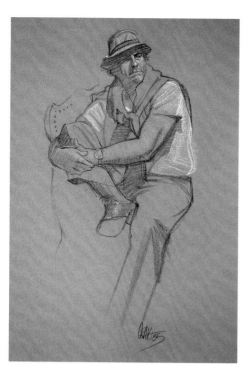

Counterbalance Your Figure
The position of the head in this casual pose counters the direction of the body and leg.

Casually Seated
Charcoal and pastel on toned Canson paper
24" × 18" (61cm × 46cm)

Use Models on Location
Try taking a model on location to sketch the figure in an outdoor environment. Look for areas where the model can feel natural, and where your work will not interrupt others.

The Sailor
Charcoal and white chalk on Canson paper
24" × 18" (61cm × 46cm)

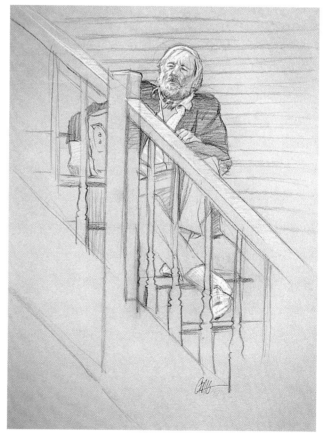

Balance

A body always strives for balance, so any action of one part must be countered by a corresponding action in another part. For instance, if a figure leans forward, its foot must also move forward to keep the figure from falling. Like-wise, a seated figure may lean to one side, but it will need an arm for support. If a torso leans or twists to one side, the legs, hips, arms and feet will react accordingly to maintain balance.

Achieving Balance
Movement requires adjustments to achieve balance. The slant of the shoulders and head is balanced by the action of the arms.

Practice
Charcoal on bristol board
14" × 18" (36cm × 46cm)

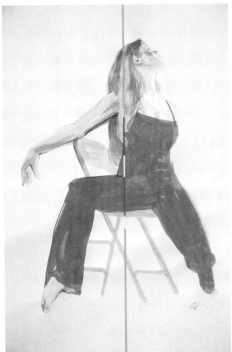

Dance Attitude
Colored inks on ledger paper
24" × 18" (61cm × 46cm)

Seated and Reclining Figures

Reclining figures also require balance. A figure rarely lies perfectly rigid. The body will always seek a relaxed position, angling the torso and hips in different directions. Arms also counter-balance the action of the hips and torso. They generally act independently of each other, often taking opposing positions.

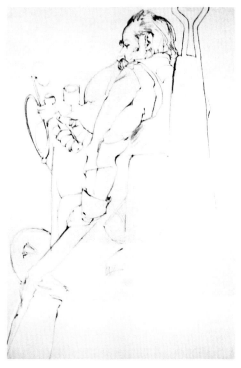

Even Static Poses Can Imply Movement
A seemingly static pose can shows a bit of movement: the shoulder is up, the head leans away and the elbow is raised.

On the Chopper
Charcoal on bond paper
22" × 17" (56cm × 43cm)

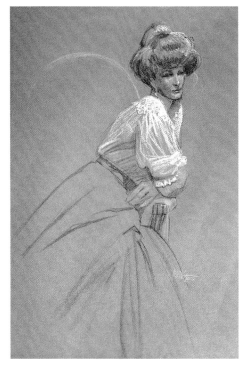

Balance in a Seated Figure
This gesture sketch demonstrates how a seated figure in an arm chair can appear more attractive. The body leans heavily to one side while the arms absorb the body's weight, creating balance.

Purely Victorian
Charcoal and pastel on toned Canson paper
24" × 18" (61cm × 46cm)

Angles

It is possible to break down complex movements into a more simplified statement. Just as proportions may be reduced to a set of measurements, gestures may be seen as simple angles and rhythms. Pure horizontal and vertical lines have no angle and are static, depicting no movement. Angles, however, lend a sense of motion. As a figure stands, sits, reclines or moves, angles play a major role in depicting that specific pose or action.

When sketching a gesture, it may be helpful to start with simple angles to depict the gist of the pose; then build your figure on that basic linear structure. This is easier than attempting to create accurate anatomy, clothing and gesture all at once.

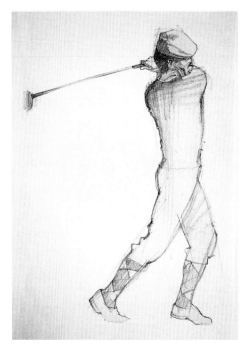 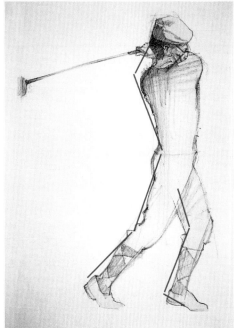

The Finale of an Action
This sketch is made up of angles, which thoroughly describe the motion of the figure and the completion of a specific movement.

The Swing
Graphite on bond paper
17" × 11" (43cm × 28cm)

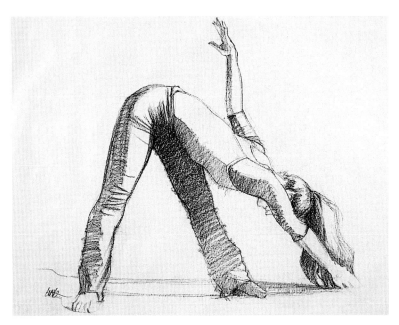

Angle Sketch
Notice that I used
simple angles
even for the arms
and hands.

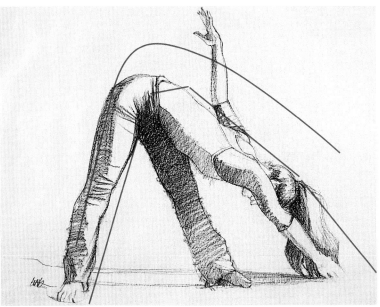

Build on the Basic Structure of Angles
This particular gesture is composed with a mixture of different angles. They oppose each other but eventually achieve a wonderful balance and solidity.

Stretch
Charcoal on gray drawing paper
17" × 22" (43cm × 56cm)

Rhythm

Visual *rhythm*, like its musical counterpart, is created by the patterns formed through repetition. Rhythm contributes a sense of movement to a composition, so the use of rhythmic patterns is particularly helpful when drawing a figure in motion. The line of an arm may be repeated in the line of the leg, creating a diagonal that moves the eye across the drawing. Stationary figures may be given a sense of animation through the use of rhythmic patterns, such as in the repeated lines in the folds of clothing.

Rhythm Adds a Sense of Movement
Any figure may be reduced to a simple pattern of lines. The interplay of lines and angles can create a rhythm that provides a sense of movement.

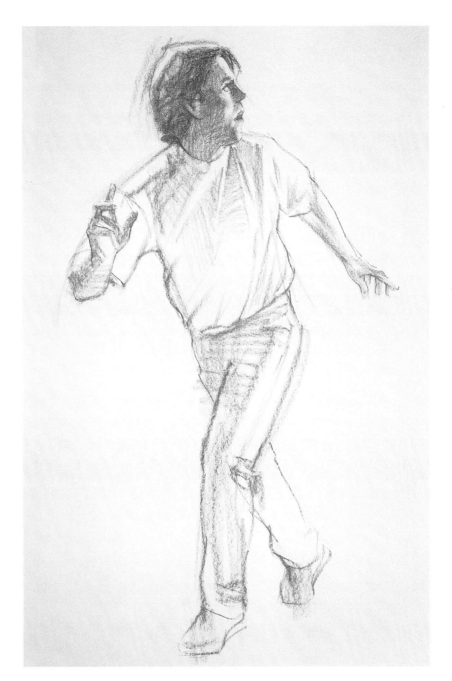

Rhythm Brings Gestures to Life
The rhythm of repeated angles results in a more animated gesture. Note the tension folds in
the shirt that are created as the torso twists.

Escape
Pastel pencil on bond paper
17" × 11" (43cm × 28cm)

Pose and Attitude

Stage actors use attitude and body language to develop their characters and enhance the story line of the play. Artists can achieve corresponding effects through the poses and attitudes they choose for their figures. Attitude can be subtle, as in a slight lift of the head, a raised eyebrow or subtle smirk, but often it is quite obvious. Attitude can involve the entire head or body, making the attitude much more noticeable.

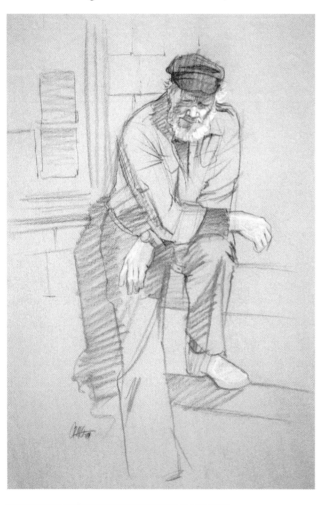

Use Pose to Indicate Attitude
The casual, relaxed attitude of this figure is reflected in the pose. Notice how the weight of the figure is distributed to achieve a sense of balance without stiffness.

On the Dock
Charcoal and pastel on gray Canson paper
24" × 18" (61cm × 46cm)

Strike a Pose

Try striking the pose you are attempting to depict so you can feel the weight distribution and achieve the proper balance.

Rendering Attitude

The viewer will understand the attitude of a figure if you render the pose accurately. Start by observing as many people as you can and do quick gesture sketches to capture the attitude implied by the pose.

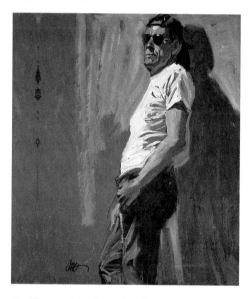

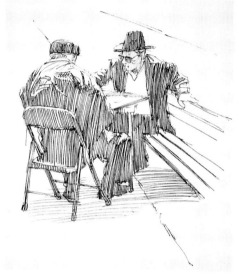

Use Lines and Angles to Render Attitude Successfully

I began this oil sketch by carefully observing the lines and angles of the figure. Once I had included the details I wanted, I added a cast shadow to add dimension to the figure leaning against the wall.

Leaning Back
Oil on rusty toned panel
18" × 14" (46cm × 36cm)

The Way Subjects Relate to the Environment Indicates Attitude

Here I placed the figures in the center of the composition to suggest the figures' interest and competition in their game.

Sketch for The Game
Fine-line pen on vellum
10" × 8" (25cm × 20cm)

Clothing Your Figures

When you draw clothing on your figures, do not draw every fold and detail. Focus only on those that are useful to your drawing. Use the lines of the clothing to help you show form and texture, intensify action or attitude, bring out the character of your subject and enhance the design of your drawing. Add tone to reinforce these qualities.

Clothing offers visual landmarks, such as a sleeve length, belt line or major fold, that may be used as measuring points on which to base proportional relationships. When you draw clothing, be sure that it conforms to the figure underneath.

Use Line and Tone to Create Folds
Here the pose is accentuated by the forms and folds of the jacket. I used tonal variation to create the folds. Notice how the detail of the folds on the sleeves enhances the design of the drawing.

Brian Painting
Pen and watercolor on ledger paper
11" × 8½" (28cm × 22cm)

Notice the use of shadows to create the appearance of folds

Folds at the side indicate the weight of the item

Vertical folds suggest the subject's posture

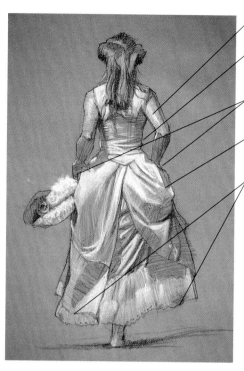

Tighter, horizontal folds wrap around the chest

Draping folds indicate the waist

Each hand is the source and destination for these folds

Folds created by the position of the hands on the clothing

Billowing folds show the figure's movement

Use Folds to Indicate Fit
Here I drew horizontal folds close together at the back to suggest the tighter fit of the top, while using wider folds to indicate the looser fit of the bottom portion of the dress.

Strolling in White
Charcoal and white Nupastel
on Canson paper
25" × 19" (63cm × 48cm)

Carefully Observe the Relation of Clothing to the Body
Notice how the shoulder seams do not exactly match up with the shoulder joint. This suggests the clothing's loose fit and the thickness of the fabric. The big, billowing folds in the sleeves add to the effect.

The Chef
Charcoal and white chalk on Canson paper 24" × 18" (61cm × 46cm)

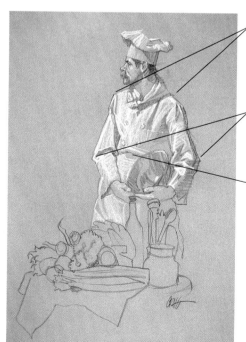

The fabric lies directly over the shoulders; folds indicate their position

Folds at the elbows to show how they are bent

A line and billowing fold indicate the waist

Drawing a Man in a Shirt and Vest

Before you begin to draw, plan for what you want to make the focal point. Here, the drawing should reflect the subject's character and the head should be the focal point. To emphasize the head, add more details and tonal variations to it than to the rest of the figure.

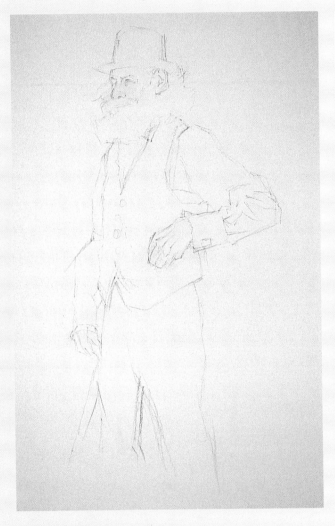

Materials

SURFACE
24" × 18" (61cm × 46cm) light gray drawing paper

MEDIUMS
4B charcoal pencil
White NuPastel

1. Sketch the Figure
Using a 4B charcoal pencil lay in a pale proportional sketch. At this point you should map out where the folds in the clothing will be. Use angles to help you render the attitude of the figure accurately.

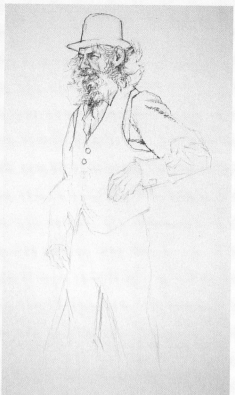

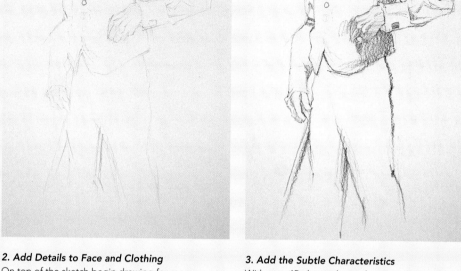

2. Add Details to Face and Clothing

On top of the sketch begin drawing for more accuracy with the 4B charcoal pencil. With the side of the charcoal pencil lead carefully add texture and movement to the clothing. Make sure your clothing conforms to the figure underneath.

Vary the type of lines you create. Keep your line-work free and casual, but hold your pencil delicately so you can vary the darkness or lightness of your marks as necessary.

3. Add the Subtle Characteristics

With your 4B charcoal pencil, continue drawing, paying attention to the more subtle characteristics, particularly where the folds in the clothing change direction rapidly (as in the armpit or elbow). These types of folds will make your drawing look realistic.

Add in a bit of tone for accent using a light amount of shading. Don't over do it.

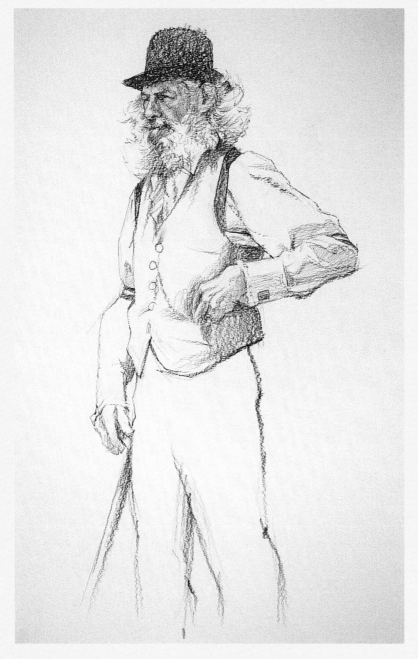

4. Finish the Charcoal Portion of the Drawing

Add the remaining soft darks and strong darks with the 6B charcoal pencil. Add more detail and tone to the face to make it the focal point.

5. Add Light and Dark Accents

Using white NuPastel and casual strokes, add the lightest lights to the face, beard and hat. Add a little bit to the shirt as an accent. Add in any dark accents that need reinforced with the 6B charcoal pencil. The contrast will give your drawing focus.

All Dressed Up
Charcoal and NuPastel on gray drawing paper
24" × 18" (61cm × 46cm)

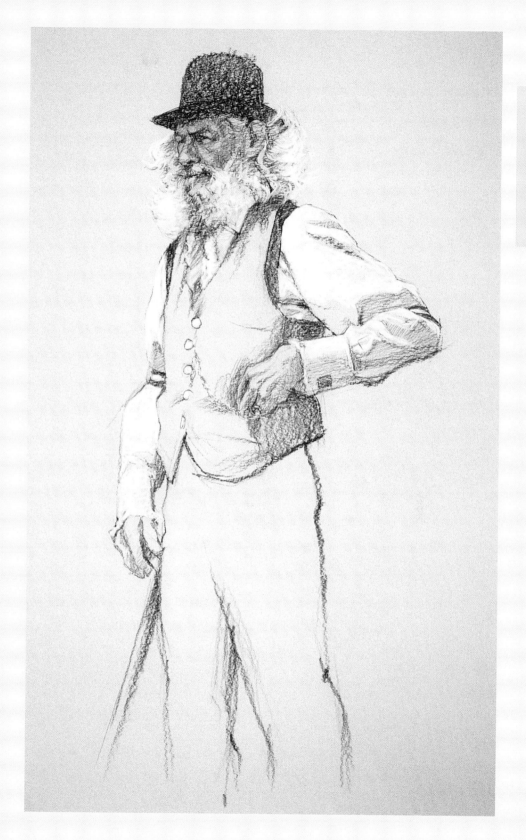

Drawing Heads and Faces

The head is usually the focus of a figure drawing, so it demands a lot of attention from the artist. Drawing heads and faces is a great challenge. It requires careful observation of proportions and values, as well as sensitivity to your materials. Heads have a variety of subtle tone changes. A delicate touch will allow the features to emerge gradually from these subtle changes in value and texture.

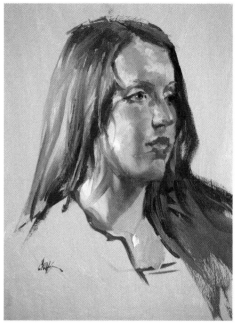

Drawing the Head Accurately Requires Attention to Detail
This young girl's head is modeled to demonstrate the forms of the head. The darker reddish hair frames the lighter flesh tones. There are two light sources, one toward the front and from the right and a brighter one far to the left.

Lindsay
Oil on toned canvas
16" × 12" (41cm × 30cm)

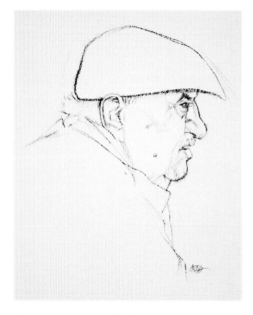

Practice Drawing Profiles First
Drawing the profile of the face is easier than drawing the front view. Once you have the outline of the profile, you can use it as a template for the face.

Proportions in Drawing Faces

Achieving accurate facial proportions in drawing requires planning, either with careful thought or tick marks. Pay careful attention to the characteristics of your subject, looking for visual landmarks from which to measure proportions.

Plan Ahead for Accurate Facial Proportions
Here you can see the relationships of features, anatomy and clothing. I drew this diagram over the initial sketch to plan and measure facial proportions.

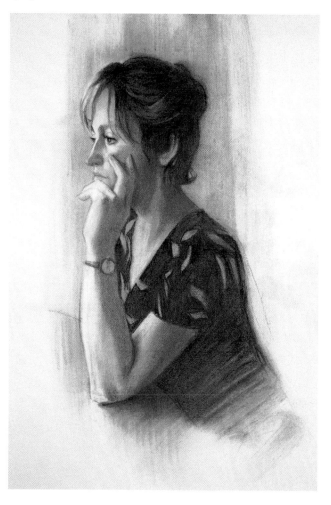

Accurate Proportions Lead to Realistic Drawings
Here, I used tones to build upon my carefully laid out proportional sketch.

Anna
CarbOthello pencil on ledger paper
20" × 16" (51cm × 41cm)

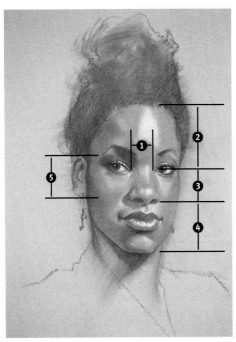

Basic Face Proportions

Once you understand these basic proportions, drawing the face becomes much easier. Mastering the head truly helps round out an artist's drawing skills.

① One eye length between each eye

② From the crown of the head to the eyes is half the length of the head

③ The nose is about halfway between the eyes and the chin

④ The mouth is about halfway between the nose and the chin

⑤ The ear extends from the brow to the nose

It's in the Eyes
CarbOthello pencils on toned Canson paper
24" × 18" (61cm × 46cm)

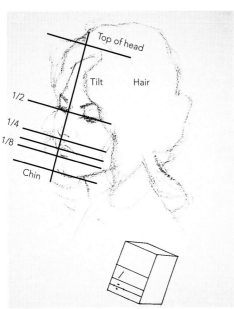

Use a Diagram to Create Accurate Proportion
This diagram demonstrates proportions for the drawing as angles on the slightly tilted head. Notice how I started out with cube, then shaped it into a face.

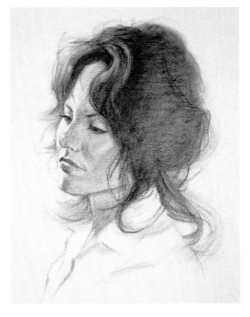

Consider the Angle and Point of View
The tilt of the head and the view's vantage point (at, below or above the subject's eye level) will affect the placement and proportions of features.

Loose Hair
Charcoal on ledger paper
14" × 11" (36cm × 28cm)

Drawing Eyes and Eyebrows

To successfully draw the eyes, you need to
know their basic structure. Use a pale sketch
to lightly indicate the placement, shape and
structure of the eyes. If your initial sketch looks
correct, develop the darker tones and marks.

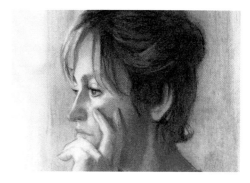

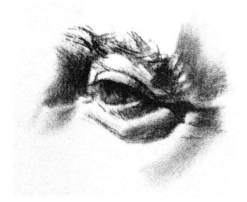

Basic Eye Structure
The eyeball fits into the eye socket and the eyelids
wrap over the eyeballs. To individualize the eyes,
vary the shape and proportions of the eye sockets
and eyelids.

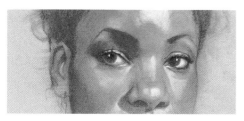

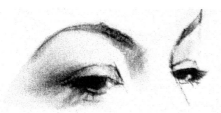

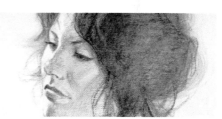

Make the Eyes and Eyebrows Work Together
Variations in the shape of the eyelids and the placement of the iris can make the eyes communicate different
things. The eyebrows also reflect emotions; make sure they reflect the same feelings as the eyes.

Drawing Mouths

Mouths can be a challenge to draw. They require the rendering of subtle details to look accurate. Understanding the basic structure of the mouth will help you render a realistic mouth. As you draw, remember that the lips protrude slightly from the face creating soft tonal variations in the skin and surrounding structures. Because of this, it's just as important for you to pay as much attention to the area around the mouth as to the mouth itself.

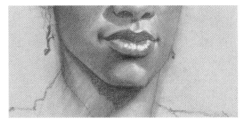

The Basic Features of a Mouth
The mouth is made up of many different planes. The junctions between planes can be either sharp or rounded.

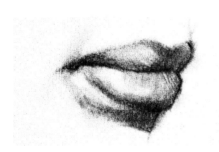

Three-Quarters View of a Mouth
Notice how the upper lip slightly protrudes and the bottom lip slightly recedes. Applying principles of perspective and modeling to the key landmarks of the mouth will make it look more convincing.

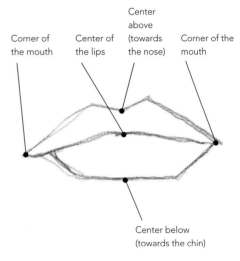

Corner of the mouth Center of the lips Center above (towards the nose) Corner of the mouth

Center below (towards the chin)

Key Landmarks for Drawing the Front View of the Mouth
Use these landmarks to draw the front view of the mouth. To change the character of the mouth, simply change the spacing of these landmarks. If you're drawing the mouth from another point of view, adjust the landmarks accordingly to render perspective and proportion accurately.

Drawing Noses

Unlike the mouth, the nose is a very solid structural feature. It has a definite front, top, sides and bottom. Draw the nose with either subtle or firm strokes to give each nose individuality. Always develop the nose slowly. Indicate the nostrils once the overall form is rendered.

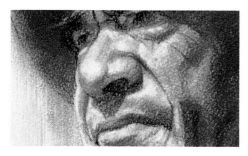

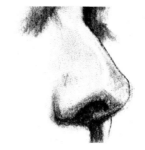

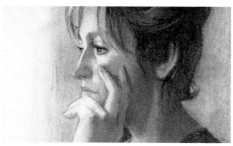

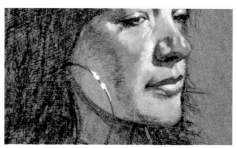

Profile of Noses
Noses come in a variety of shapes and sizes. Start with the basic shape, then add the details.

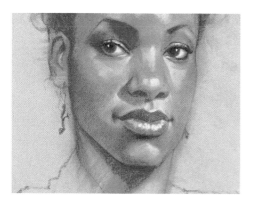

Make the Mouth and the Nose Work Together
The facial structures that surround the mouth are connected to the nose, too. Make sure your drawing reflects this connection.

Drawing Ears

With all its folds and wrinkles, the ear seems like a difficult part of the face to draw, but as long as you get the basic shapes right, it isn't that hard.

Basic Shape of the Ear

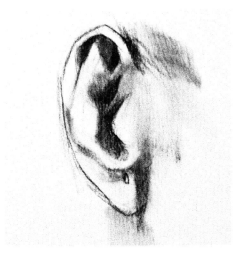

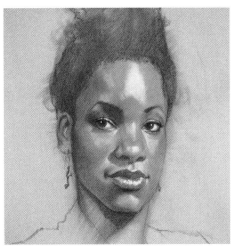

Ear on the Face

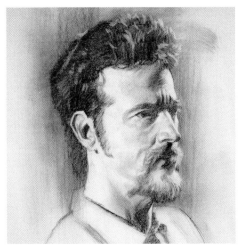

Three-Quarter view of the Ear

Male Faces

The basic shape of the head is the same for men and women, but the details make them different. Male facial features tend to be more pronounced. When drawing a male face, your value contrasts and structural definition will be more obvious.

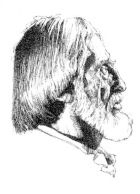

Make Male Features More Defined
I used crosshatching to build up the features for this profile.

Beard Profile
Fine-line technical pen on cast-coated paper
16" × 12" (41cm × 30cm)

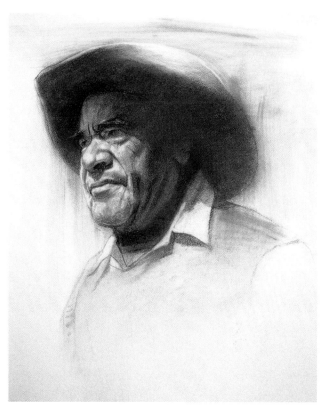

Use Variation to Add Character
The values on this head are built from light, reddish tones to deep browns in the rich darks. I used a tissue to smear the tones together and a kneaded eraser to recapture lighter details. I also added some crisp line work for contrast.

A Hat for Shade
CarbOthello pencil on toned Canson paper
20" × 16" (51cm × 41cm)

Drawing a Male Face

DEMONSTRATION

The features on male faces tend to be more pronounced than those of females. In this demonstration, the way the model's head is posed shows off the nose structure, eye sockets and firm jawline. I also adjusted the lighting to amplify the form and create a lot of shadows and midtones on the face. Two lights illuminate the head, a dominant light from the front and another light in the back.

Materials

SURFACE
24" × 18" (61cm × 46cm)
white drawing paper

MEDIUMS
4B and 6B charcoal
pencils

OTHER
Facial tissue
Kneaded eraser
Workable spray fixative

1. Sketch the Subject
With a 4B charcoal pencil, lightly sketch the contours of the face. Be sure to note the widths and lengths of the features and the relationships among them.

Get The Pose you Want

Position models first, then observe them from different angles and directions. This will help you find a pose that suits you.

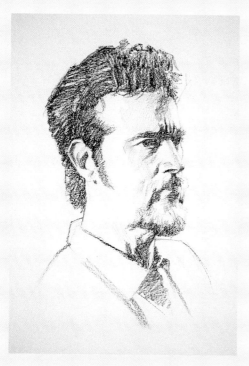

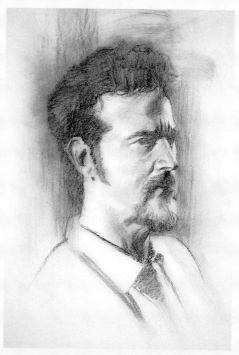

2. Add Details With Tonal Variations

Lay in the tonal variations on the head with a 4B and a 6B charcoal pencil. Use the 4B for lighter tones such as the shadow on the face and neck, and the 6B for the darker shadows and hair. Don't worry about the rough texture of the tones.

3. Blend the Tones

Use a tissue and your index finger to smudge the tones into the lights and the background. The darker background tones will provide a contrast with the lighter face. If necessary, darken the hair and other areas again and smudge with your index finger.

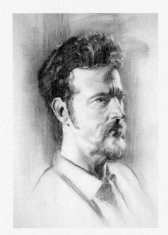

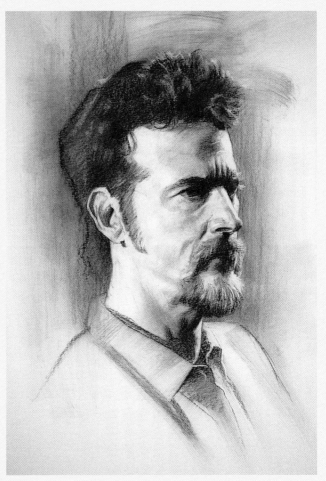

4. Lift Out the Lights
Use a kneaded eraser to lift out the lights and model the highlights on the form. Clean up any areas that are lit and defined with your kneaded eraser.

5. Add the Finishing Details
Spray the entire drawing with a light layer of workable fixative and allow it to dry. Use a sharp 6B pencil to refine areas that need more definition. Add darker tones where you see them, such as around distinct feature changes in shadow. Smudge if necessary.

The Near Profile
Charcoal on white drawing paper
24" × 18" (61cm × 46cm)

Female Faces

Drawing female heads generally requires more refined modeling than drawing males. Women's features are usually softer and more delicate than those of men. This requires a more sensitive touch with your medium. It is best to understate the value changes, especially in the beginning stages of the drawing. Dark accents should be minimal and applied only at the end.

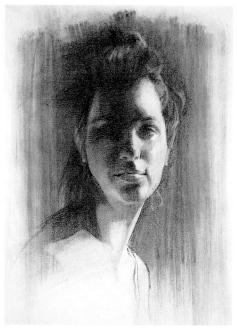

Front View of a Female Face
This side-lit head is more in shadow than in light. Within the shadows, there are subtle details of features and reflected light on the jaw line.

Lauren
Charcoal on drawing paper
16" × 12" (41cm × 30cm)

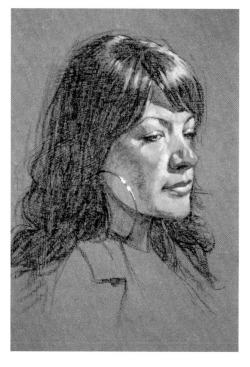

Profile of a Female Face
Notice that the nose in this profile drawing is more rounded and the lips are fuller than those of most male faces.

Drawing a Female Face

A drawing of the female head has softer and more subtle forms than that of a male head.

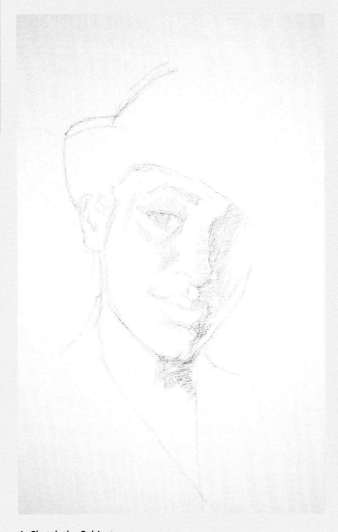

Materials

SURFACE
24" × 18" (61cm × 46cm)
drawing paper

MEDIUMS
Selection of CarbOthello
pencils in light, medium
and dark earth-tones

OTHER
Facial tissue
Kneaded eraser
Workable spray fixative

1. Sketch the Subject
Using a light earth-tone CarbOthello pencil, lightly sketch the contours.
Pay careful attention to the proportions of the facial features.

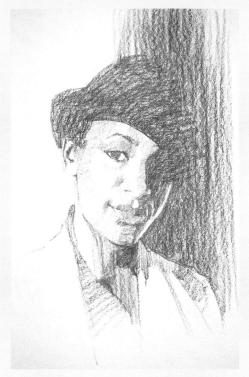

2. Add Shadows

With a medium-value earth-toned CarbOthello pencil, lay in a basic shadow tone on the head and into the background. Apply this color to the dark local tone of the hat.

3. Blend the Tones

Use a piece of facial tissue to lightly smudge and smear the tones. Use your index finger to smudge the smaller areas.

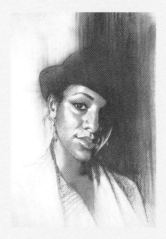

4. Apply Darker Tones and Lift Out the Highlights

Add darker tones with a darker CarbOthello pencil. Blend these colors together. Lighten, clarify and refine where necessary with a kneaded eraser.

5. Complete the Drawing

Apply a light layer of workable fixative to the drawing and allow it to dry. With the darkest CarbOthello pencil, lay in the darker toned areas and blend them with a tissue. Apply linear accents for refinement.

The Derby
CarbOthello pencil on drawing paper
24" × 18" (61cm × 46cm)

Caricatures

Caricature drawing is an exaggerated, usually humorous type of portraiture. It concentrates on the distinctive features and shape of the head. This takes careful observation of an individual's unique visual characteristics. Exactness in proportion is not a priority. Instead, the proportions, shapes and sizes of the features are exaggerated to add a degree of humor to the drawing. If the eyes slant down, if the nose is broad, if the cheekbones are pronounced, if a lip is large, or if the face is narrow, you can overstate these features, creating an amusing likeness.

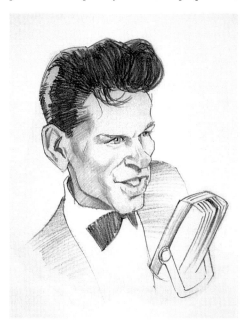

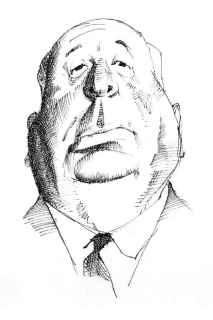

Focus on the Head
Here I exaggerated the youthful bone structure and pushed the expression of the eyebrows, nose and mouth to create this caricature of a youthful Sinatra.

Young Sinatra
Eagle draughting pencil on vellum
10" × 8" (25cm × 20cm)

Emphasize the Subject's Unique Features
The rounded, bony cranium is offset by the chubby cheeks. A unique mouth configuration is quite noticeable as depicted through exaggeration.

Mr. Hitchcock
Fine-line technical pen on vellum
10" × 8" (25cm × 20cm)

Index

Blending, 19, 22, 27, 32
Boards, 46
Burnishing, 27

Canvas, 47
Caricatures, 93
Charcoal, 12, 17–19, 48–49, 59
 characteristics, 18
 paper for, 43–45, 54
 pencil, 17–18, 52, 55, 86–88
 techniques, 19
Clothing, 33, 57, 69, 72–77
Colored pencils, 12, 24–29
 characteristics, 25
 techniques, 26–27
 water-soluble, 24–25, 28–29
Conté, 12, 20–23, 59
 characteristics, 21
 techniques, 22–23
Crosshatching, 16, 27, 32, 85

Drawings, 50–52

Ears, 80, 84
Erasers, 13, 16

Face, 78–93
 female, 89–92
 male, 85–88
 proportions, 79–80
Features, facial
 eyebrows, 81
 eyes, 80–81
 mouth, 80, 82–83
 nose, 80, 83
Figures, posing, 57–71, 86
 angles, 66–67
 attitude of, 57, 59, 60
 balance, 62, 64–65, 67, 70
 contrapposto, 60
 multiple, 59
 proportions, 58
 rhythm, 68–69
 testing, 58
Foamcore, 47

Gesso, 46, 49
Graphite, 10–12, 14–16, 44
 characteristics, 15
 techniques, 16
Grays, building, 46, 49

Hatching, 16, 41, 53
Heads, 74–76, 78–93

Ink, 13, 37–41, 44
 characteristics, 38–39
 pens and brushes, 38
 techniques, 40
 types of, 39
 with watercolor, 41

Layering, 27, 32
Lighting, 78, 86
Lines
 charcoal, 19, 48
 Conté, 21
 contour, 33, 51
 graphite, 15–16
 hard, 50–51
 pen, 33
 soft, 52
 working with, 50
 See also Crosshatching; Hatch-
 ing

Markers, 33

Paper, 28, 31, 43–48
 toned, 20, 43, 49, 54, 59
 tooth, 19
Pastel, 12, 30–32, 43–44, 90–92
 characteristics, 31
 techniques, 32
Pens, drawing, 33–36
 characteristics, 34–35
 techniques, 36

Shadows, 16, 71–72, 86–88
Sketching, 47, 58–59, 71
Surfaces, 42–49

Texture, 16, 19, 42, 48
Tone, 50, 53, 55
 lifting, 16, 19, 88, 92
Tools, 13–14, 17, 30
Traveling, 29

Value, 48, 54–55

Watercolor, 10, 13, 41

Other fine North Light Books are available from your favorite bookstore, art supply store or online supplier. Visit our website at www.fwmedia.com.

15 14 13 12 11 5 4 3 2 1

DISTRIBUTED IN CANADA BY FRASER DIRECT
100 Armstrong Avenue
Georgetown, ON, Canada L7G 5S4
Tel: (905) 877-4411

DISTRIBUTED IN THE U.K. AND EUROPE
BY F&W MEDIA INTERNATIONAL, LTD
Brunel House, Forde Close, Newton Abbot, TQ12 4PU, UK
Tel: (+44) 1626 323200, Fax: (+44) 1626 323319
Email: enquiries@fwmedia.com

DISTRIBUTED IN AUSTRALIA BY CAPRICORN LINK
P.O. Box 704, S. Windsor NSW, 2756 Australia
Tel: (02) 4577-3555

Cover Designed by Wendy Dunning
Interior Designed by Brian Roeth
Production coordinated by Mark Griffin

About the Author

Craig Nelson graduated with distinction from the Art Center College of Design in Los Angles, California, in 1970. He began teaching in 1974 and currently teaches painting and drawing at the Academy of Art College in San Francisco, where he is Department Director of Fine Art.

His work has appeared on many record album covers for Capitol Records, Sony and MGM. He has also painted many portraits for various stars including Natalie Cole, Neil Diamond, Rick Nelson, Sammy Davis Jr. and Loretta Lynn.

Craig has won over two-hundred awards of excellence in various national shows including being selected for the Arts for the Parks competition for the last eight years. His work can be found in several galleries throughout the United States and continues to appear in exhibitions both nationally and internationally. His paintings also appeared in the book, *Art From the Parks* (North Light Books).

Craig is a member of the Oil Painters of America, the American Society of Portrait Artists and a signature member of the California Art Club. He resides in northern California with his wife and three children.

Metric Conversion Chart

TO CONVERT	TO	MULTIPLY BY
Inches	Centimeters	2.54
Centimeters	Inches	0.4
Feet	Centimeters	30.5
Centimeters	Feet	0.03
Yards	Meters	0.9
Meters	Yards	1.1

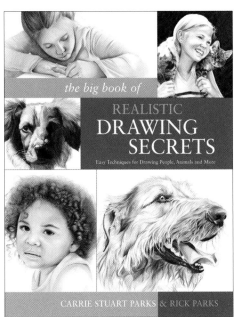